# REMBRANDT

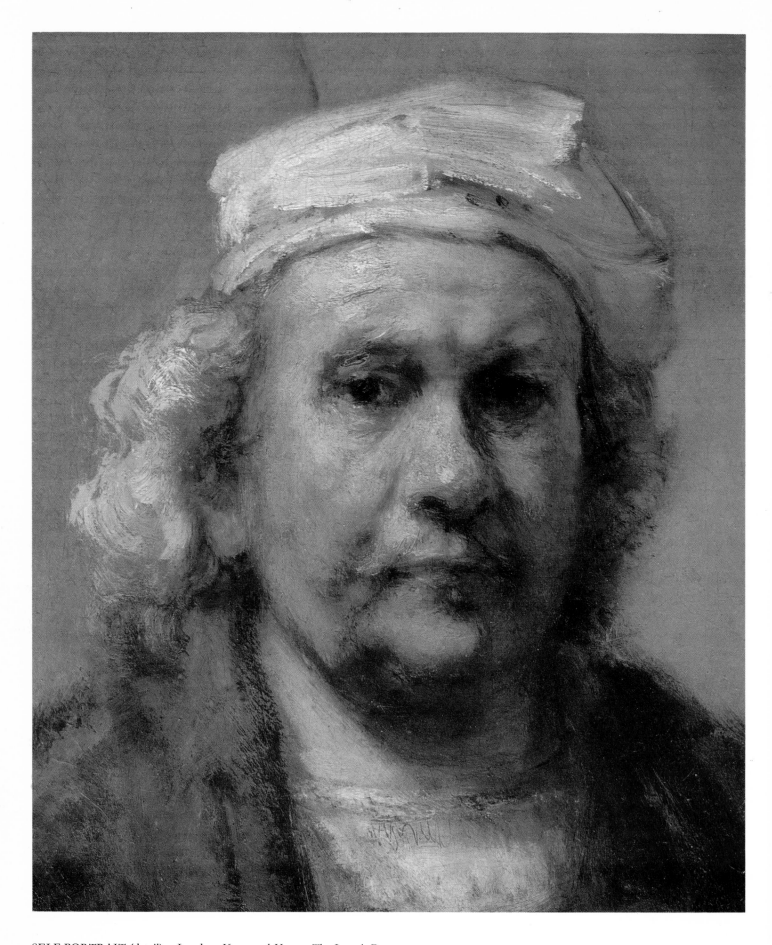

SELF-PORTRAIT (detail). London, Kenwood House, The Iveagh Bequest

# REMBRANDT
## by Michael Kitson

with fifty plates in full colour

© 1969 Phaidon Press Ltd · 5 Cromwell Place · London SW7

Phaidon Publishers Inc · New York
Distributors in the United States: Frederick A Praeger Inc
111 Fourth Avenue · New York · N.Y. 10003

Library of Congress Catalog Card Number 68–27419

SBN 7148 1348 6

Made in Great Britain
Text printed by Hunt Barnard & Co Ltd · Aylesbury · Bucks
Illustrations printed by Ben Johnson & Co Ltd · York

# REMBRANDT

If we stand in the Rembrandt room of a major picture gallery, what visual impressions do we receive and how do they differ from the impressions we receive from other rooms in the same gallery?

To begin with, we notice dark backgrounds broken by irregular patches of light. There is more dark than light, and the light is not often taken up to the frame. Instead, it lies towards the centre where it balances the dark and acts as the focus of the greatest interest. Usually there are both black and white in the picture, the black occurring in a robe or hat, the white in a collar, cuffs or else in a headcloth or shirtfront. The frames are also sometimes black. Black and white represent colours – the only unmodified colours in the picture – but they also register as extremes of light and dark tones.

Otherwise the paintings are rich in colour but it is not pure or evenly applied colour; nor is the composition divided into fields of different colours as in Renaissance or modern painting. Even in Rembrandt's early works the colours are broken and changing, like a brocade woven with gold or silver threads or like the glowing embers of a fire. In the highlights and deepest shadows the colours almost disappear. In the middle tones they deepen and become more intense in one of two directions: either towards red (vermilion or madder lake) or towards greenish-gold. It is typical that Rembrandt uses these colours as alternatives, not together, so that red and green seldom appear in combination. He generally avoids colour contrasts and complementaries and prefers colours close to each other in the spectrum. Brown, orange or yellow are mixed with or appear beside red; yellow or dull green accompany and merge into greenish-gold. Grey is also used with his two main colours. Blues, violets, pinks and bright greens, however, occur only in pale tints and in subordinate positions. The early paintings are generally cool in colour, the mature and late ones warm, with red predominating. Like the strongest lights, the strongest colours are confined to only a comparatively small part of the picture. The effect is of a surge of colour coming from within the form rather than of colour decorating the surface, defining the form's shape.

The backgrounds are also of no single colour but are made up of dull browns, greens and greys, usually blended together but in the late works sometimes laid on side by side. Unlike the backgrounds of some Italian baroque painters, Rembrandt's are never flat or opaque but are filled with atmosphere and penetrated by reflected light. (Only uncleaned paintings by Rembrandt give an impression of solid dark brown in the shadows.) These more subdued neutral colours register as tones. Tone, or rather *chiaroscuro*, is the basis of Rembrandt's art. Colour, however important and beautiful, is contingent. It may be quite strong or very restrained; some paintings are almost monochromatic, and a few are executed in *grisaille*. But whatever its strength, colour is an adjunct. The scheme of the composition is established by the *chiaroscuro*. Colour is applied in some parts, where it attracts the eye and heightens the emotional tension, but not in others. Only in certain late works does colour become a semi-independent medium, and even occasionally predominate (cf. pl. 43). Elsewhere it is integrated with the *chiaroscuro*. This is the principal means both of 'keeping together the overall harmony' (as Rembrandt's earliest biographer, Sandrart, put it) and of creating a poetic mood; it is also a source of aesthetic pleasure and of luminous and striking effects in its own right. Rembrandt's mastery of *chiaroscuro*, in all its degrees from the darkest darks to the strongest lights, has been acknowledged ever since his own time.

In composition, Rembrandt's paintings are essentially simple and stable and are built up from the edges towards the centre. Secondary lights, colours and forms are subordinated to primary ones. Rembrandt does not divide up the design into self-contained units or distribute the interest among different areas. Visually the design obeys a principle of hierarchy. Except in his earliest works there is no sense of overcrowding or strain. Movement continues to be represented slightly later (during his 'baroque' period) but after a while this too largely disappears. At all stages of his development his figures possess great authority and presence. They are set against a background which is vague and neutral enough not to compete with them yet which is everywhere visually interesting. Thus the background forms part of the design, it is not a mere backcloth. It also serves to relax the tension which exists at and near the centre and to effect a smooth transition from the imagined world of the main action or figure to the real world of the spectator.

Elegance, *contraposto*, the harmony and balance of parts – those foundations on which the beautiful rests in Renaissance painting – are conspicuous by their absence. Except in Rembrandt's most baroque paintings there are no swinging lines and few three-dimensional curves or forms leading the eye into depth. He sometimes borrows from, but is never dependent upon, conventional formulas of the ideal and the beautiful. He uses flat, often rather fastidious and simple shapes lying parallel to the picture surface, especially in his late period, but not graceful, sweeping contours or variations of the S-curve common to mannerist, baroque and rococo painters. When he does introduce a curving or flowing line he interrupts its rhythm with some irregular twist or sudden change in pace. Generally speaking, flowing lines are weak in Rembrandt; energetic lines are jagged or straight. In some of his late works he builds up a pattern of rectangles and triangles, and occasionally a large circle or disc appears in the background. After the early years of his career, in keeping with his unwillingness to use a stressed contour, he tends to avoid figures and faces in profile. He prefers to contain the most interesting visual effects within the contour of the form, as in the *Old Man seated in an Armchair* (pl. 30), in which the right arm and hand only just graze the outline of the head and are otherwise wholly included within the form. The placing of a hand in repose in front of rather than to one side of a figure is a favourite device.

To an unusual degree Rembrandt's art – not only in his portraits but also in his subject pictures – is dominated by faces; few of them are handsome and many of the most remarkable are old. Their watchful eyes are indistinct and often in shadow except for a line of light along the lids. His faces are always expressive and habitually tense. An urge to communicate thought, feeling and experience is imprinted on them. Although partly shadowed, they are seen in close-up, as if the artist were peering at them and they were returning his gaze. From the works of few other artists do we get such a sense of watching and of being watched. It is not an accident that about two-thirds of Rembrandt's paintings are portraits (including some fifty of himself). Most of the rest in our hypothetical Rembrandt room will be scenes or figures from the Bible. In addition, there will probably be a mythological scene, a landscape and perhaps a *genre* scene or still life. The paintings are likely to vary greatly in size and to range from the very small to the quite large.

Permeating all Rembrandt's works of whatever category and size is an air of solemnity and mystery. He is not a frivolous or merely sensuous artist, nor does he delight in beauty of colour or brushwork for their own sake. When colour and brushwork are beautiful, as they often are, they are so for expressive rather than decorative reasons. Moreover, the solemn and the mysterious are attributes of Rembrandt's style, not merely

of his attitude to the subject matter. To veil forms, textures and colours, leaving something for the imagination to fill in, is central to his method. A tone, a background, suggests more than it states; the eye can only trace out its implications so far. The world of Rembrandt's paintings is certainly as imaginary as that of any painter working in an ideal style. He does not take us into the open air or reconstruct a real interior. Yet, unlike the world of most such painters, his is not raised above nature; it appears to us rather as an intensified vision of nature's essential reality. Rembrandt reverses the normal procedure of idealizing artists. Whereas they transform the essence of things and leave a reminder of nature in the details, he preserves reality in the essence and clothes its outward forms with a mysterious beauty and suggestiveness.

It is useful to begin thus by recalling some of the aesthetic characteristics of Rembrandt's paintings, because for over a hundred years the praise of Rembrandt has often been less aesthetic than moral. His work has been treated as the product not so much of a visual artist as of a superior, almost God-like personality. The emphasis has fallen on his possession of qualities of character: dedication, humanity, compassion, spiritual and psychological insight, courage to ignore fashion and to refuse to flatter patrons, above all, unswerving devotion to 'the truth' – the truth about himself, his sitters and the events and characters of the Bible. These qualities are immediately attractive nowadays. We admire integrity and the spirit of independence in artists. Nor is it intrinsically an error to see Rembrandt in this light, although it is possible to exaggerate the extent to which he possessed some of the virtues attributed to him. Nevertheless it is important to be aware of what has happened, so to speak. That is to say, we should realise that much of the modern bias in Rembrandt appreciation is due to developments in art criticism since his time and that what we see in his work may not have been present, either to the minds and eyes of his contemporaries, or in the consciousness of Rembrandt himself. For some reason this problem is particularly acute where Rembrandt is concerned. It may be so partly because contemporary information about his *art* is very hard to obtain, whereas his personality – and hence by unconscious inference his mind – is deceptively accessible, through documents relating to his life, through his self-portraits, through his portraits of his family, and so on. But whatever the reason, the result has been to divert attention from Rembrandt the artist to Rembrandt the man. Thus there has emerged a sentimental cult of Rembrandt, which is not by any means confined to popular or old-fashioned literature; this cult presents us with Rembrandt the home-lover, the paragon of virtue and the sage.

It is not easy to tell how far the modern Rembrandt, even without the sentimental distortions, is the invention, and how far the discovery, of later critics. It would be as foolish to ignore the insights of the past hundred and fifty years as it would be to accept them without question. What is certain is that they were made possible by a radical shift in the methods of criticism which began in the Romantic period. The practice of previous critics had been to assess the qualities of a work of art by examining the work itself; the tendency now was to look beyond the work and to seek for the key to its qualities in the artist's mind. The significance of this development for the understanding of Rembrandt is so great that it is worth discussing a little further.

Until the Romantics, works of art had been judged by more or less objective standards: whether they were beautiful or ugly, true or false to nature, and whether or not they were treated in accordance with certain rules. They were examined piecemeal, under the headings of drawing, colour, composition, etc. With the coming of Romanticism, standards became at once more comprehensive and more subjective. Sincerity was used as a criterion of artistic judgement for the first time and new kinds of truth were brought

into the argument. Was the artist true to his own inner vision and experience (that is, was he sincere)? Did he, as Goethe expressed it, 'love what he painted and paint only what he loved'? Was he true not just to the letter but to the spirit of his subject matter? In this way the critical interest was shifted from the work of art to the artist's total attitude.

As a result of these developments, what had previously been regarded as faults or at best limitations in Rembrandt came to be considered merits. His 'low' subjects and interest in and association with the poor, the old and the Jews, which had been condemned as undignified, now marked him out as the champion of the downtrodden and the oppressed; hence the concept of Rembrandt's compassion arose. His broad brushwork and disregard of the rules of proportion and anatomy, which had been thought ignorant and eccentric, were now interpreted as a refusal to sacrifice his convictions for the sake of easy fame; hence came the idea of Rembrandt's integrity. His common, naturalistic style, once thought fit only for comic and vulgar subjects, was now felt to be better suited to scenes from the Bible than the ideal style of the Italians, since those scenes took place in humble surroundings and were enacted by humble people; hence the discovery of Rembrandt's spiritual insight and regard for truth.

The question of the special appropriateness of Rembrandt's style for religious subject matter is of particular interest, as it has played so large a part in modern criticism and in forming the popular image of Rembrandt today. Probably the first to discuss this point was Goethe, in the essay from which the phrase quoted earlier was taken (*Nach Falkonet und über Falkonet*, 1776). This essay already contains, in essence, everything that has been said on the subject since, and says it with a moderation not always found in later writings. Rembrandt is seen as having created a new form of religious art, as valid in its way as Raphael's was in another way. Indeed, his style had the advantage over Italian Renaissance painting in being truer than the latter to the spirit of the Bible, and hence of being fresher and more capable of communicating the Christian message with an appropriate directness and force.

'If Rembrandt represents his Madonna and Child as a Dutch peasant woman, everyone sees that something decisive has occurred in defiance of history, something which proclaims: Christ is born in Bethlehem of Judea. The Italians have done it better! says the lover of painting. And how? – has Raphael painted anything other, anything more, than a living mother with her first-born and only son? and what else is there in the subject to paint? And is mother-love in its joys and sorrows not a fruitful subject for poets and painters in all ages? But there are religious paintings, from which all simplicity and truth has been drained away and all sympathetic feeling withdrawn, by cold finishing and ecclesiastical propriety, to deceive the staring eyes of the insensitive. Does not Mary sit between the scrolls of altar-frames, before the shepherds, with the Child there, as if letting Him beg for money? or as if, after a four-week rest, with all the leisure afforded by her confinement and prompted by feminine vanity, she had prepared for the honour of this visit? Now that's decent! that's proper! that doesn't upset history!

How does Rembrandt treat this subject [the late etching of *The Adoration of the Shepherds*, fig. 7]? He places us in a dark stable; necessity has driven the mother, the Child at her breast, to share a bed with the cattle. They are both wrapped to the neck in straw and rags, and everything is dark outside the glow from a small lamp which shines on the father, who sits there with a small book and appears to read Mary a prayer. At this moment the shepherds enter. The foremost of them, who advances with a stable-lantern, peers, taking off his cap, into the straw. In this place the question was plainly uttered: Is the new-born King of the Jews here?'

The key to this passage lies in the change of tone at the beginning of the second paragraph. No-one before had described a composition by Rembrandt so literally and so sympathetically or had so well caught its spirit of simple humility. Here for the first time is Rembrandt presented as the painter of and for the human heart.

As has already been said, these considerations are not irrelevant or invalid. There is no doubt that Rembrandt did introduce a new kind of religious art, based on a literal rather than symbolic interpretation of the Bible. What is more, whoever looks at his work, and not only at his religious paintings but also at his portraits and even landscapes, cannot help seeing it as a moral as well as aesthetic achievement. But while this is true, it is a method of approach to Rembrandt which lies in the background of this essay, whose purpose is, rather, to return to an older tradition of criticism and to discuss his paintings as works of art. Its theme is Rembrandt the artist. We see a painting of *The Holy Family with Angels* (pl. 23). It strikes us as simultaneously domestic and sacred, lively and serene, intimate and deeply moving. How were the tones, colours and brushmarks disposed to produce these results? This is the type of question that will chiefly concern us.

# REMBRANDT AS AN ARTIST

Although little information relating to Rembrandt's art (as distinct from his life) has come down to us, such as it is it is not negligible and is worth briefly recalling. It appears chiefly in the following sources: the three earliest biographies of Rembrandt, by Sandrart (1675), Baldinucci (1686) and Houbraken (1718); a treatise on painting by one of his pupils, Samuel van Hoogstraten (1678); the journal of Constantyn Huygens (who visited Rembrandt and his colleague Lievens in Leyden in or about 1629); a small group of letters to Huygens from Rembrandt; the inventory of his collection of works of art (both by himself and by and after other artists), weapons and curios, drawn up at his bankruptcy in 1656; and, last but not least, his own work. By this is meant, not his work in its entirety, but those aspects of it, particularly drawings and etchings, which reveal through their subject matter the personal background to his activity as a painter. This is not the place to examine these sources in detail, as the information contained in them is often indirect and would require lengthy interpretation, but some general points emerge which are worth discussing in relation to Rembrandt's practice as an artist.

Not unnaturally, the three early biographers of Rembrandt judged him by the standards of their own time. They were by no means insensitive to his qualities and they found him to be an artist of extraordinary power. They praised his colour and *chiaroscuro* and Houbraken particularly stressed the variety and vividness of the poses of his figures and their facial expressions and gestures. On the other hand, they criticized him for being weak in drawing and for neglecting the classical rules of proportion and anatomy, especially in his treatment of the nude. His paintings were believed to be unfinished owing to their broad brushwork and heavy impasto, and he was scarcely mentioned as a painter of religious subjects; rather, he was regarded (at least by Sandrart) as a *genre* painter who mostly chose subjects to please himself from the daily life around him.

In regarding Rembrandt in this way the biographers were applying the standards of ideal art. Nowadays it is generally agreed that these standards are largely irrelevant. However, this does not mean that Rembrandt's attitude to them was one of simple rejection, still less that he was unaware of them. Even though he never visited Italy he had ample opportunity to study Italian paintings, drawings and engravings in collections and at auction sales in Amsterdam (as he told Huygens); he could follow the example of those

of his predecessors, including his teacher Lastman, who had been to Italy; and he could read, in Dutch, Van Mander's 'Didactic Poem' on painting, published in Haarlem in 1604 as a preface to his *Lives of the Artists*, in which the theory of ideal art was fully explained. Up to a point, in fact, this theory must have furnished the aesthetic assumptions on which his own art was based – if only because there was no other articulated body of theory available. Two of its principles in particular apply: the doctrine of the superiority of history painting over all other *genres*, and the importance of illustrating a subject and depicting the emotions appropriate to it by means of gestures and facial expressions. As to the first, it should be remembered that, despite the biographers, Rembrandt was a 'history painter' hardly less than Raphael or Rubens, although of a very different kind. His works, like theirs, were scenes from sacred history and (less often) classical history and mythology – imaginative in conception, moral in content and serious in mood. So anxious was he from the first to succeed in this branch of art that he never painted a commissioned portrait in his Leyden years. It is further evident that, although there was no demand in Holland for paintings to decorate churches, Rembrandt's religious pictures, not to mention his etchings, often found buyers among private collectors. Rembrandt's interest in the illustration of the subject and the rendering of emotion is even more significant. Overtly and dramatically in his early period, more subtly in his middle and later years, Rembrandt was one of the great story tellers of art. This did not mean only that he chose a promising situation or narrative and depicted it clearly, but also that he extracted the utmost emotional significance from it. His earliest self-portraits (cf. pl. 1) are exercises in expression, and in his subject pictures throughout his career he showed feelings – in faces and in the way people stood or sat and used their hands – with a vividness and variety unsurpassed in painting. Rembrandt's skill in this art was noticed early in his career by Huygens as well as some time after his death by Houbraken. It was also the subject of the one revealing comment on art in Rembrandt's own letters, which are otherwise predominantly about money. Describing to Huygens (12th January 1639) the *Entombment* and *Resurrection of Christ* (fig. 3), which he had just completed for Prince Frederick-Henry, Rembrandt states that in them he had represented 'the greatest and most natural movement' (*die meeste ende die naetureelste beweechgelickheyt*). There is some doubt whether the last word in this phrase should be translated as movement or emotion; in fact it probably implies both (there is a similar double meaning in the English word 'moving') since mobility of poses, faces and gestures was the normal means by which emotion was expressed. In this way the phrase would be applicable not only to the *Resurrection*, in which there is a great deal of violent physical movement, but also to the outwardly calmer, though equally emotional, *Entombment*. It is an interesting coincidence that, in the same year, Poussin was writing in the same sense (but at much greater length) to his patron, Chantelou, about the depiction of the passions in *The Gathering of Manna*.

However, Rembrandt's awareness of the theory of ideal art and his acceptance of two of its most widely known principles did not mean that he was deeply interested in this theory or that he adhered to it uncritically. Although he probably had a number of aesthetic maxims which he was fond of repeating to his pupils (who in turn passed them on in garbled form to the authors of the early sources), it is unlikely that he had any fully-fledged artistic theory. And in some important respects he positively rejected the principles of ideal art. According to both Sandrart and Hoogstraten, he laid particular stress on the imitation of nature, even going so far as to state that 'the artist should be guided by nature and by no other rules'. This, if true, would have been a direct contradiction of classical principles, according to which artists should use the rules and the

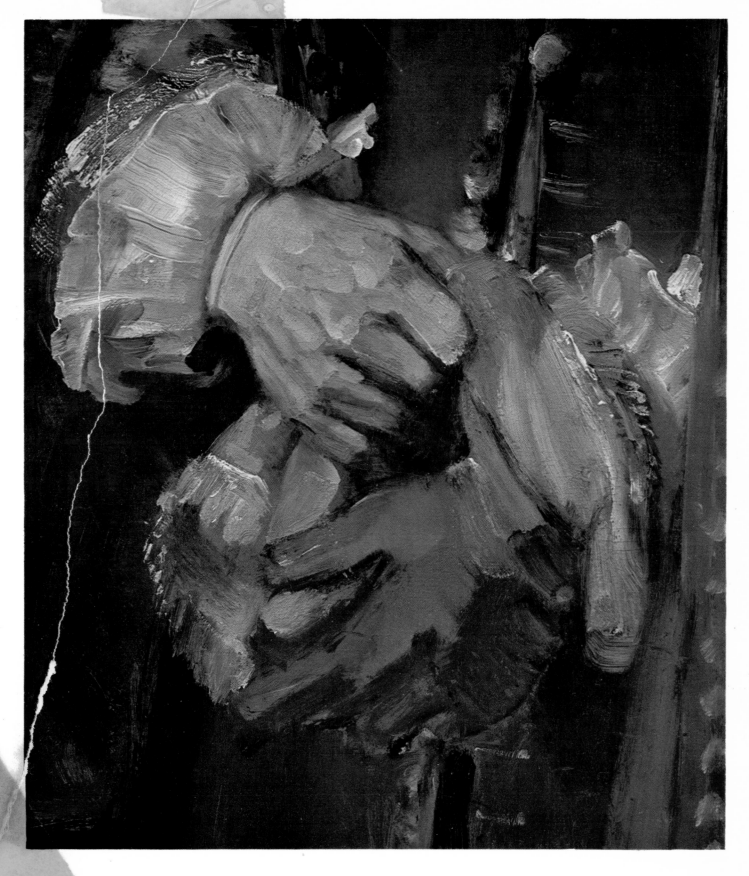

DETAIL OF THE HANDS FROM THE PORTRAIT OF JAN SIX REPRODUCED AS PLATE 36.    1654.    Amsterdam,
The Six Foundation

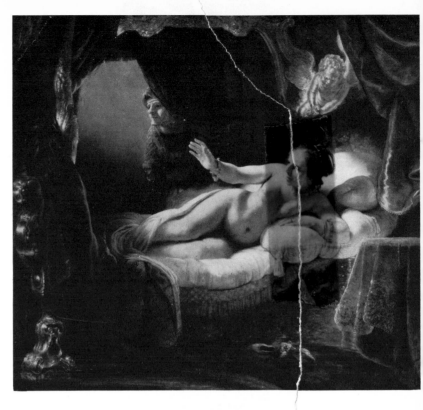

Right. Fig. 1. DANAË. 1636. Leningrad, Hermitage

Below right. Fig. 3. THE RESURRECTION OF CHRIST. 163(9?). Munich, Alte Pinakothek

Below. Fig. 2. SASKIA (?) WITH ONE OF HER CHILDREN (detail). Red chalk. About 1635. London, Count Antoine Seilern

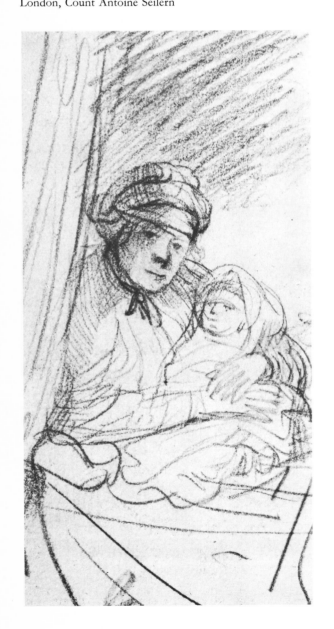

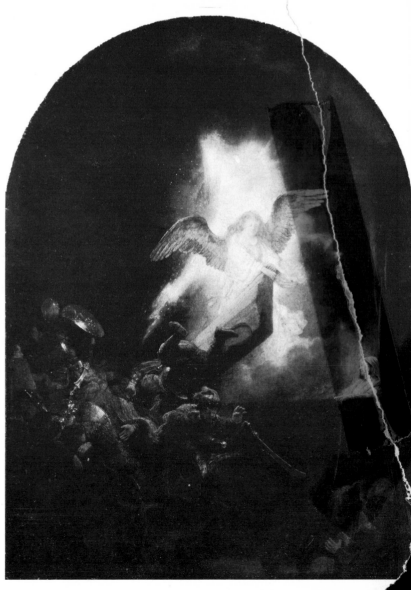

example of the art of the past as a means of 'correcting' nature. Furthermore, Rembrandt was not concerned with the doctrine of decorum, or the matching of style with subject matter. Nor was he committed to following the Antique, or Raphael, or the classical ideal of beauty, although he made use of all three on occasions and although his collection contained many examples of classical sculpture, either in the original or in casts, and several complete sets of engravings after Raphael. Whenever he referred to these sources in his work or painted a nude or a figure in some classical attitude, he produced a free adaptation. Even if only slightly, he undermined the system of ideal art at the point where it was most vulnerable: in its rule of internal consistency. He would interrupt the flow of a form with a quirk of realism, thicken (say) the proportions of the legs in relation to the rest of the body, or make the weight of the figure greater than its form would lead one to expect. And he did all this, unlike his Flemish and Dutch predecessors who had only half understood the classical rules, without sacrificing the organic unity of the figure or of the painting as a whole.

In his early period one can see Rembrandt almost 'attacking' the Antique. He represents the youthful Ganymede abducted by the eagle as a yelling, urinating baby. Two or three years earlier he produced a black chalk drawing of a Rubensian *Diana*, in which he made the arms and legs thinner, the flesh flabbier and the face more innocent than Rubens would have done. He subsequently used this drawing as the basis of an etching, removing the bow and quiver of Diana, adding still more creases to the flesh and turning the result into a study of an embarrassingly realistic naked woman. The object of these exercises was surely to strike a blow against art on behalf of nature, and hence on behalf of artistic freedom. But Rembrandt's destruction of the classical rules of art was also a means of understanding them. Out of this understanding grew the *Danaë* in Leningrad (fig. 1), Rembrandt's nearest approach to a traditional classical nude. But by the standards of Titian even this is imperfect; the head and hands are too large, the facial expression is too eager and one breast is pressed out of shape by its position against the left hand. After these early experiments Rembrandt's confrontation with classicism is never so direct or thoroughgoing, either in acceptance or rejection. In his later work it is subtle, unexpected and oblique.

Freedom is the keynote of Rembrandt's relationship not only to the classical ideal, but also to other styles and traditions of art. One could make similar comparisons between his art and that of Dürer, Leonardo or Titian (who is perhaps the artist with whom his affinity is closest, although the mutual resemblance in their late work may be a coincidence). Drawing nearer Rembrandt's own country and time, there are parallels to be found with Elsheimer, Rubens and Seghers. Rembrandt's use of all these – and other – sources was selective and flexible. We have seen one example of the way in which his flexibility showed itself: in his treatment of ideal art. But the implications of his method go much further than this. He could paint 'high' subject matter in a 'low' style (breaking the rule of decorum). He could combine the beautiful and the ugly, the majestic and the intimate, the supernatural and the real. While accepting the traditional obligation to illustrate a story and represent emotions in his figures, he succeeded in evolving a new, naturalistic method of doing this. It was a method quite different from that originally devised by Italian Renaissance artists, which elsewhere in Europe during his lifetime was hardening into a formula. As will be seen later, Rembrandt's method was in effect no method, but an apparently spontaneous depiction of feelings in figures which depended as much on the context and the *chiaroscuro* and brushwork as on the movements of the facial muscles or gestures.

Furthermore, with Rembrandt the compartments in which the different categories of

painting had traditionally been kept tend to break down. Religious subjects may be treated like *genre* scenes (cf. pl. 2); portraits may merge in one direction into paintings of saints or mythological characters (pl. 11), in another direction into studies of anonymous models (pl. 37). There is only one distinction which Rembrandt maintains: that between subjects appropriate, respectively, to drawings and to paintings (his etchings typically lie in between, overlapping each of the other two groups). Whereas his drawings include many *genre* scenes, *genre* figures and naturalistic landscapes studied from the life, his paintings on the whole do not. As a painter, Rembrandt was concerned with man as a human and spiritual being, and to have shown man in his paintings in the passing context of his day-to-day environment and activities, as he did in his drawings, would have detracted from this concern. Thus, after a few early experiments he abandoned the painting of *genre* scenes, and transferred the element of *genre* into the representation of domestic scenes from the Old and New Testament. Nor was this merely a nominal transposition, for the whole character of the subject is subtly altered, not just its outward details. In these paintings, a common Dutch pictorial form – the *genre* scene – and a deeply rooted social preoccupation – the home – are given a heightened poetic significance by their treatment as a religious subject.

It would be possible to see this characteristic in Rembrandt as a kind of humanism, and hence as the expression of an attitude similar to that which underlay the theory of ideal art. Nor would this be wrong, provided we interpret his expression of that attitude as, typically, a very personal one and regard his preoccupation with man's humanity more as a spontaneous development in him than as the product of any obvious outside influence. Moreover, it is reflected not only in his assimilation of *genre* subject matter to religious art, but also in his treatment of the painted single figure which was neither a portrait nor a character from the Bible or classical mythology. It is customary in catalogues and convenient for purposes of discussion to classify these figures as '*genre* studies'. But this is precisely what they are not, for they lack that distinguishing feature of *genre*, namely the element of anecdote and the hint, however slight, of activity. Rembrandt's single figures do nothing but think. To call such figures as the *Old Man seated in an Armchair* or the *Two Negroes* (pl. 46) *genre* studies is to diminish their significance.

There is also something else. Just as these paintings have a more profound *content* than other Dutch paintings of single figures, so they have a less explicit *subject*. It is impossible to attach an allegorical label to them, like one of the Five Senses or *Vanitas*, any more than they can be called figures drinking, playing music, reading a letter or trying on a pearl necklace, for they do none of these things. Their lack of subject in the ordinary meaning of the term may be reflected in Sandrart's report that Rembrandt painted subjects 'that are ordinary and without special significance, subjects that pleased him and were picturesque (*schilderachtig*), as the people of the Netherlands say.' As a critical comment this is misleading, as it implies that Rembrandt was motivated by that idle curiosity which produces *genre*, yet the absence of an identifiable subject in these paintings was sufficiently remarkable for Sandrart to think it worth recording. It may even be the case that some of Rembrandt's paintings in which the figure is dressed in an exotic costume may belong to this category. These figures are usually interpreted nowadays as characters from the Bible – preferably obscure ones to account for the difficulty of identifying them convincingly. But Rembrandt may not have intended anything so specific, at least when he conceived the figure, although he may have attached a name to it afterwards. Perhaps even the famous and mysterious '*Polish Rider*' (pl. 32), over which modern scholars have speculated endlessly in the attempt to find a title that would fit, is a painting of this type. Be that as it may, Rembrandt's development of the single-

figure study with no explicit subject as a serious independent art form was not the least of his contributions to the future of European painting.

Lastly, Rembrandt disregarded the convention that art was a 'polite' profession, an activity requiring private feelings to be kept in the background. Hitherto, if an artist drew or painted himself or members of his family, he did so as a sideline apart from his other work. Rembrandt, on the contrary, freely used his mother, father, wife, mistress and children as models in his paintings, either as themselves or disguised as religious or mythological figures. He also repeatedly made spontaneous drawings of them (fig. 2) in pen and ink or chalk. No previous artist had derived so much inspiration from what was personal and familiar to him or had so mingled the private and the public in his art. The supreme examples of this are his self-portraits.

# THE SUBJECT PICTURES

The term 'subject pictures' here covers paintings, whether of religious or mythological themes, in which a situation or story is represented. In this section we shall be concerned with the way Rembrandt developed his style and technique in these pictures, which for obvious reasons usually contain two or more figures. The problems of the single figure, which have already been touched on, will be discussed further in the next section, under portraits.

Rembrandt's earliest subject pictures (pls. 2, 3) are small, crowded and highly finished. They are designed to be examined minutely at close range. In style and often in subject they depend on his teacher, Lastman; they also contain echoes, transmitted through Lastman, of the intense, exotic art of Elsheimer. Their subjects tend to be taken from some minor episode in the Bible or from ancient history, which lent itself to the narrative treatment familiar to contemporary Dutch artists. As paintings they are primitive and awkward. Their forms are lumpy, their poses complicated, and each figure seems to have been studied on its own, to be joined to the others afterwards. Hands gesticulate, eyes are beady and mouths drawn down. The flesh even of quite young figures appears to be shrivelled up like a wizened apple. There is often a figure in the foreground in shadow seen from the back (pl. 3). It is evident that, like many young artists, Rembrandt was keeping a close eye on the art around him and, knowing he would be judged by its standards, trying to outdo it. We can sense him hoping to win through by a display of skill. He would expect each figure to be admired in turn. At the same time, he was bolder than Lastman, who seems by comparison frightened of stepping outside the classical rules. He avoids Lastman's generalized forms and draperies; from the start Rembrandt is concerned with the particular. An individual vein of appealing sentiment informs the *Anna and Tobit* (pl. 2), and there is an intriguing ambiguity about the figures in the *Two Scholars Disputing*. Who are they? Are they really scholars? named Greek philosophers? Old Testament prophets? These things strike a new, arresting note.

About 1630 Rembrandt steps back, as it were, from the subject and places the figures in the second plane in a high vaulted space. Perhaps attracted by indirect knowledge of Caravaggio, he makes the observation of a pool of light surrounded by darkness the visual motive of the picture. Where there is only one figure, this figure is often represented in contemplation or asleep, so that the shadowy atmospheric space above appears as an emanation of thought or dreams. Visually it is as if Rembrandt were standing at a distance watching the light as it fell from a high window in a dim Gothic interior. Similar but not identical means are used for the depiction in this setting of

a lonely scholar seated by a window and the *Presentation of Jesus in the Temple* (pl. 7). The difference is that, whereas in the secular scene the light has a visible source, in the latter the natural light is fused with a supernatural radiance emanating from the figure group; yet this is done so subtly that we are only subconsciously aware of it and the way the light falls strikes us at first glance as natural. Rembrandt was to use this device again and again in religious pictures in the future.

The composition of the *Presentation* is absolutely calm. No-one moves or speaks but everyone looks. It is a picture about looking, about understanding through the eyes. In the central group, gazes are fastened on Simeon holding the Christ-Child; he returns them in the direction of the high priest whose lost profile is in shadow. Other figures – grave Rabbis seated in the foregound, a more excited crowd dimly visible on the steps to the right – watch from a distance. Two old men from the crowd have come forward to join the central group, peering over Mary's shoulder. We recognize in them the many pen and ink studies of beggars which Rembrandt made from life at this time (fig. 5). Thus is reality blended with sacred history. The solemn mood leaves us in no doubt that we, like the onlookers in the painting, are witnesses to a divine revelation.

Within the scheme of light and shade, the composition is defined by lines: verticals in the figures and architecture, horizontals and receding diagonals along the steps and the divisions in the pavement. The vertical emphasis, which rises to a climax in the pillar to the right of centre, above the Infant Christ, rests on a firm base. The figures are also lineally conceived, but the lines fall as much within the forms, following the folds in drapery, as they do along their contours. We are again reminded of Rembrandt's drawings of this period, in which he used long looping strokes, hardly lifting his pen from the paper. The colours are cool and close to one another in the spectrum; the brushwork is delicate and the surface smooth and luminous like deeply polished wood, echoing the wooden panel on which it is painted.

*The Presentation in the Temple*, executed in 1631 about the time that Rembrandt left Leyden for Amsterdam, is one of his first masterpieces on a small scale. But, regarding his career as a whole, we must take account not only of the intimate, closed, spiritual Rembrandt; there is also the open, monumental, baroque Rembrandt to be remembered. Perhaps initially the decision to work on a large scale was the desire to emulate Rubens, who deeply affected Rembrandt's art in the early 1630's and was, after Lastman, the most important single influence in his career. Rubens's richly plastic modelling, though not his composition, is already reflected in the heads of *The Anatomy Lesson of Dr. Tulp* (pl. 9 and fig. 12), with which Rembrandt made his reputation on his arrival in Amsterdam. Like most of Rembrandt's group portraits this is partly a subject picture, since it contains an action and figures responding to it. The painting represents a private dissection, which would have preceded or followed the public one held by the surgeons' guild. Dr. Tulp is shown demonstrating the muscles and tendons of the forearm and comparing his findings with a diagram in a recently published book on anatomy, which has been identified. Nevertheless, the composition is as much that of a group portrait as of a documentary record, and the action, in addition to being basically true to life, is a device for unifying the picture. What contemporaries would have admired is Rembrandt's virtuosity as an artist: his invention, the vividness of the expressions, his smooth brushwork and skilful foreshortening of the naked corpse. In Amsterdam in 1632, this was what painting was about.

*Belshazzar's Feast* (pl. 12), another large work of this decade which exhibits similar qualities, is still more ambitious. Whether it is equally successful is another question. Rembrandt, here unhampered by real life, gives his imagination free rein. It is a painting

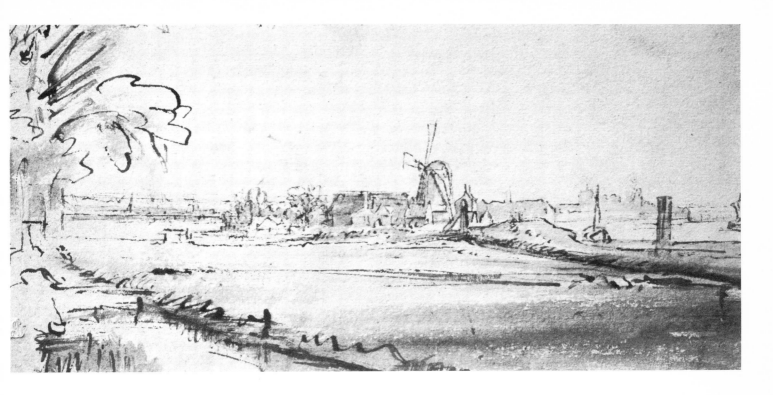

Fig. 4. LANDSCAPE WITH A WINDMILL. Reed-pen and wash in bistre. About 1654-5. Vienna, Albertina

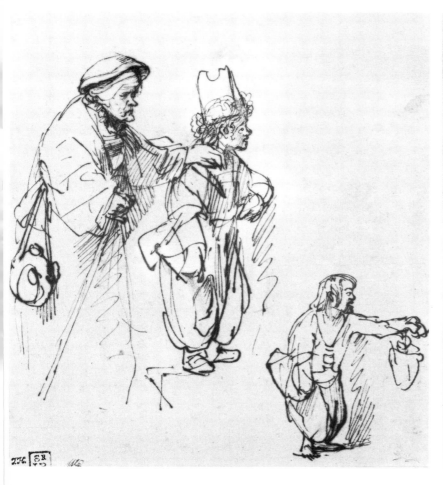

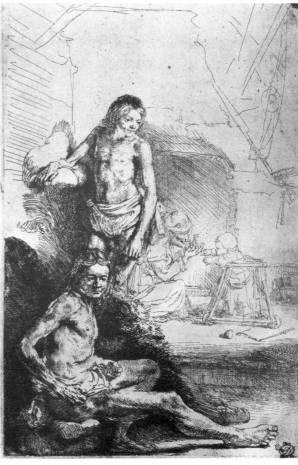

Fig. 6. STUDIES FROM THE NUDE. Etching.
About 1646. London, British Museum

Fig. 5. SHEET OF STUDIES. Pen. About 1633-4. Berlin, Kupferstichkabinett

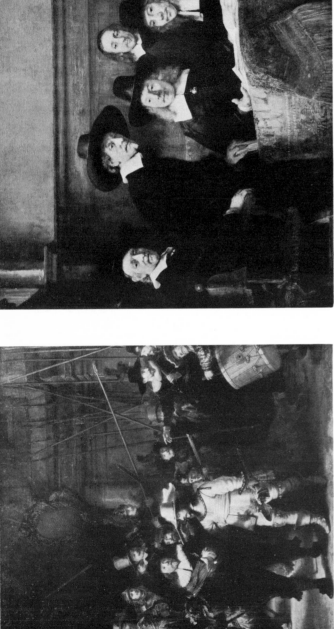

Fig. 11. THE SYNDICS. 1662. Amsterdam, Rijksmuseum

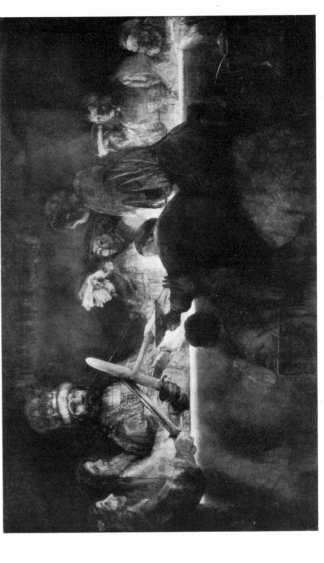

Fig. 13. THE CONSPIRACY OF JULIUS CIVILIS: THE OATH. About 1661-2. Stockholm, Nationalmuseum

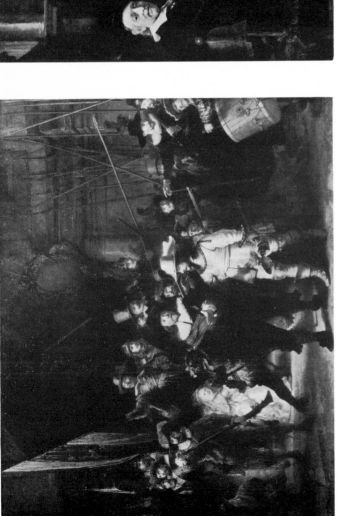

Fig. 10. "THE NIGHT WATCH." 1642. Amsterdam, Rijksmuseum

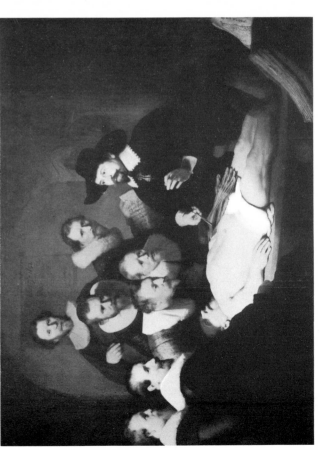

Fig. 12. THE ANATOMY LESSON OF DR. TULP. 1632. The Hague, Mauritshuis

designed to impress. It displays difficult technical problems chosen and overcome: not only expression but lighting, movement and the treatment of exotic still-life accessories and costumes. Much is made of the play of both direct and reflected light on surfaces. This is especially true at the left (detail, pl. 8), where the woman seated in the foreground seems literally bathed in irridescence. Softer, partly reflected light glances over the two figures facing Belshazzar, while another figure almost lost in shadow hovers dimly in the background. On the right a swaying, foreshortened figure reflects the influence of Venetian painting both in pose and in the painting of the red velvet sleeve. The composition is defined by powerful baroque diagonals anchored at the centre by the massive body of Belshazzar and focussed on the great jewelled clasp of his cloak. The impasto is very thick and heavily worked in this area, as if mimicking the substance it is representing. The cloak, turban and trinkets would have been modelled on the bizarre costumes and curios with which Rembrandt stuffed his studio wardrobe.

This is perhaps Rembrandt's most purely theatrical painting. Everything in it is emphatic, exotic and astounding. Yet for most modern critics it is a failure. It seems to be too lacking in other qualities. The dramatic event which touches off the action – 'the Writing on the Wall' – is sensational enough to justify the rhetoric but we feel that Rembrandt is trying too hard. Wine spilling not just from one but from *two* goblets is too much. The expressions are overdone and the painting of Belshazzar's face and hands is ugly and grotesque. But it is at least – with some of the early self-portraits – a corrective to the sentimental view of Rembrandt. Only he could have carried off such a monstrous performance.

After this, Rembrandt progressively diminishes the area in which rich costumes and precious metals appear, yet until the last decade there is usually a hint of such richness somewhere in the picture, of brocades or burnished metals glowing like fire. Rhetoric also dies away and, from the early 1640's onwards, outflung arms and grimacing features – the outward, baroque means of conveying emotion – are replaced by subtle hints of feeling in the eyes, set of the head and pose.

The transition to a new kind of art was effected in a number of tranquil scenes painted during the 1640's, the common theme of which is domestic piety. We find this epitomized in the Old Testament (*Manoah and his Wife, Tobit and Anna*) as well as in the New (*The Holy Family*, pl. 23, and *The Adoration of the Shepherds*). No mythological subjects were painted during this decade, even among the single figures. The most typical single figure is the impoverished, bearded old man, hatless or wearing a simple cap, seen head and shoulders only, and the young servant girl appearing at a window (pl. 25). Whether this withdrawal into a more intimate kind of art was occasioned by reaction (Rembrandt's, not his contemporaries') against the bombast of the '*Night Watch*' (pl. 17 and fig. 10), by grief at the death of his wife, or by factors in his own interior life, is uncertain. Rembrandt's own thoughts and feelings, as distinct from their manifestations in his appearance (as seen in his self-portraits) lie outside our knowledge.

Perhaps the most significant development – it is even more important than the subject and composition – consists in the technique. A simple way of putting this is to say that the brushwork becomes broader, but there is more to it than that. The change affects the whole treatment of form. An alternative explanation might be to suggest that the top layers of paint have been left off and that the surface now visible is what would previously have been the underpainting or a sketch; in other words, one might describe the paintings, as the early critics described them, as unfinished. In fact they are not unfinished, nor did Rembrandt simply substitute sketches for finished pictures. On the whole he did not make preparatory sketches in oil except for some of his early etch-

ings. Nevertheless, the analogy with the sketch and the first stages of a painting is one way of understanding the process by which the new technique was achieved. A glance at the monochrome sketch of the *Entombment of Christ* (pl. 18) will illustrate this, as it shows what happens at its simplest and most extreme. Not only are the surfaces of the forms left out but the transitions between tones are omitted as well. A stroke of paint is used simultaneously to indicate the tone of a form and its approximate shape. Differing tones are placed side by side instead of being blended into one another. This brushwork is a kind of 'note form'. It is functional and without embellishments; it does not suggest movement or texture; it denotes rather than describes.

It could not be more different from the more highly finished parts of earlier paintings, like the *Presentation in the Temple*. There the brushwork follows the contours and internal modelling of the forms, describing their surface minutely. The tones are blended, the stroke is soft and linear. This even applies to more vigorously handled comparatively late works of the 1630's, like *The Risen Christ appearing to the Magdalene* (pl. 22). It is only in subsidiary parts of these paintings, which are not meant to attract the eye particularly and where the forms are slightly indistinct, that the simplified brushwork of the 'forties is anticipated. (Contrary to what might be expected, it does not seem to be anticipated in Rembrandt's most personal, and therefore most freely handled, early paintings, such as his portraits of himself and his family; the brushwork in these is looser but its descriptive character is the same as that of other works of the period.)

However, there are differences as well as similarities between Rembrandt's technique in his finished paintings of the 'forties and his sketches. For one thing, speed is of the essence in a sketch, and Rembrandt was not interested in speed; Baldinucci records that he was a slow worker, going over passages again and again, waiting for each layer to dry, until he was satisfied with the result. More important, the brushstrokes in the finished paintings of this period (cf. *The Holy Family with Angels*, pl. 23) are very refined and their shape is carefully calculated. Each one is unobtrusive yet of the utmost significance. It conveys simultaneously form, colour, texture and tone. To some extent the last three could be adjusted later by means of glazes but the form had to be exactly right from the first; its shape had to be defined exactly by the mark made by the brush. In some of the figures in smaller works, a complete head or hand may be represented by a single brushstroke, without modulations of tone. No more than three or four strokes are required for the headcloth of the Madonna in *The Holy Family with Angels*; another single broad stroke suffices for the piece of this cloth which comes over her right shoulder. In still later works (cf. the detail of the hands from the portrait of Jan Six), proportionately fewer strokes are used for more complex forms. Nor are there many different tones in these forms. The main tonal variations are expressed by juxtaposition, not by blending. The slight changes which suggest the play of light and atmosphere over the forms are obtained by glazes. One advantage of this broader yet very precise method of handling was that Rembrandt could make larger, seemingly 'empty' areas visually interesting. He could avoid the fussiness which characterizes many of his paintings of the previous decade (pl. 22). What earlier or contemporary painter could have made so commonplace an object as a child's wicker cradle seem so fascinating to the eye? The paint has a beauty in itself, over and above its representational function.

The brushwork also had another purpose: to represent emotion. Rembrandt was no longer interested in conveying expression by exaggerated facial movements, that is to say, by movements which he could describe by tracing their outlines with the brush. He knew that human emotions are often expressed by only very slight changes in the facial

muscles – perhaps only around the eyes and at the corners of the mouth – changes which the observer in real life is able to pick up but which are too subtle to be represented by conventional formulas of expression. By placing the brushstroke just 'so', in the cheek below the eye or along the eyelid, Rembrandt was able to record these tiny movements and hence to imply the expression in the eye itself. This gave him, further, the power to convey a whole range of emotions that were outside the capacity of previous artists. This applies particularly to the inward or contemplative emotions of love, compassion and apprehension, as distinct from the outgoing and active ones of terror and rage. In his middle and later years Rembrandt hardly ever represented figures in violent states of feeling. Moreover, his mastery of expression was not confined to the treatment of faces; it is also evident in his painting of hands and indeed the whole body. No painter has made so much of the touching of one figure by another with a hand: the Angel laying a hand gently on Daniel's shoulder in *The Vision of Daniel* (pl. 28); the Elder fingering (not snatching at) Susanna's shift in *Susanna surprised by the Elders* (pl. 29); *Jacob blessing the Sons of Joseph* (pl. 33); Mary reaching out a hand to lift the cloth from the Child's cradle without waking Him (pl. 23).

The technical characteristics which have been discussed are epitomized in this last most beautiful and central painting of Rembrandt's middle years. To study it is to realize that what can be described as technique is not a dry mechanical dexterity but the counterpart of imaginative and spiritual qualities. Here is the familiar theme of the Madonna and Child represented in the costumes and setting of a *genre* scene (Goethe's 'Dutch peasant woman') but made sacred, not just by the presence of angels, but by the colour, expressions and brushwork. By keeping the colours and lighting very pure and by a slight emphasis on the regularity of certain forms – the line of Mary's shoulder, the oval of her face, the smoothness of her brow – Rembrandt invests the figure with a sweetness which proclaims that this is no ordinary mother but the Mother of God.

In Rembrandt's late art this sweetness is avoided. It is an art largely dominated by men: the Madonna hardly reappears; the characteristic female figure is *Lucretia* (pl. 47). Many of the paintings are large. The figures are almost all life-size and are usually shown in three-quarter length. The conception of the pictures is monumental and austere, although it may encompass moods both of great tenderness (*The Prodigal Son* in Leningrad) and agonized jealousy (*David playing the Harp before Saul*, pl. 39). The dark curtain between the two figures in the second of these paintings is heavy with the threat of danger (there is perhaps a hint of a revival of Caravaggism here, as in one or two other late works). Equally, the late pictures may include a strain of vivid realism, as in the *Two Negroes* (pl. 46); or they may summon up ghosts. What apparitions are they, what survivors of some unknown Northern mythology, that gather round the table to swear the oath in *The Conspiracy of Julius Civilis* (pl. 43)?

However, we are more conscious of what unites the late works than of what divides them. The trend is away from realism and narrative, and towards essence rather than existence. Even the expressions are often mute or inscrutable; the figures think and feel but no longer communicate as before. They embody a kind of super-real presence which is all the more intense for being without corresponding form or rational cause. The observation of light and shade is less illusionistic than before. The brushwork also almost ceases to have a representational function and to become, instead, an independent medium. We often cannot tell the material of which the costumes are made. The paint, applied in square over-lapping patches, layer upon layer, scratched with the handle of the brush, scraped off and reapplied, has its own extraordinary character, its own vitality. The marks scarcely define the shape of forms; like the penstrokes in the late

drawings or the drypoint lines in the late etchings (fig. 7), they lie outside or within, not along, the contours. Blocked in with straight edges, they serve as lines of force, indicating direction.

The forms, though massive in area, are insubstantial and flattened, and limbs that would normally be seen in foreshortening are sometimes distorted in order to bring them into a plane parallel with the picture surface. The integrity of the picture surface is all. What we see is a tapestry of colours and tones into which figures and faces are dimly yet palpably woven. A greater number of different tones and different shades of the same or related colours, each distinct yet harmonized with the others, are visible than in the work of any other artist, not even excepting the late Titian. The effect is at once dream-like and intensely vivid; subtle and overpoweringly impressive. Like the late work of some other great artists, Rembrandt's is essentially tragic. As the mind contemplates it, it is purged of the emotions of pity and terror and brought to a state of peace.

# THE PORTRAITS

In discussing Rembrandt's portraits it is difficult not to begin with the *cliché* that he was the greatest portrait painter of all time. This statement does not take us very far; and if true, it imposes an obligation on the critic to explain why it should be so. At all events, it will generally be agreed that Rembrandt embodies most of our ideas of what a great portrait painter should be. We think more highly of that type of portraiture which reveals character than of that which reveals mere likeness. We expect a portrait to uncover 'the real man', to show him warts and all and to disclose the private weaknesses behind the public face. We would rather that the painter were the critic than the flatterer of his sitters. Further, we ask that a portrait should tell us as much about the artist as about the person portrayed; that it should be the product of a collaboration between the two, the end in view being the creation of a work of art.

Now, these are democratic expectations, most of which previous ages did not share. It happens that Rembrandt – in a sense – satisfies them; the fact that he does so is one reason for his popularity today. But Rembrandt fulfils the modern requirements of portraiture to both a greater and lesser extent than might be expected. As usual, his method is not reducible to a formula; nor is it easy to group his portraits and single figures into categories for purposes of discussion. Although they all have some things in common, each turns out on examination to be a unique achievement.

The painting of a portrait poses two main artistic problems. The first, which applies to all representations of the single figure, is how to avoid monotony. It is one failing of the second-rate portrait painter that all his figures, apart from their features and sometimes clothing, tend to look alike. Even the very good portrait painter of the second rank, like Frans Hals, may, by emphasizing the pose and introducing gestures and movement, achieve only a superficial variety, since if these factors are overstressed they appear contrived. Rembrandt generally keeps the poses of his sitters quiet and unassuming, although they are never dull, and he rarely uses gesture or movement. Except in his earliest self-portraits the expressions are also restrained, and this becomes increasingly true in his later work; there is always something withheld from, as well as given to, the observer. Rembrandt's chief means of gaining variety are, one, the use of costumes and attitudes which show the sitter adopting a role (this is not confined to portraits of himself and his family, although it is most clearly evident there); and, two, the creation of a mood of introspection or internal drama, into which the observer finds himself

drawn. This mood stimulates curiosity and produces a suggestion of 'content' which is like that of subject paintings, not just of portraits, and hence is capable of similar variations. By concentrating on the sitter's psychology, sometimes emphasizing one side of his personality by showing him acting a role, Rembrandt achieves a more genuine variety than he would have done if he had used more superficial means.

The second problem of portraiture is that of representing character. Ever since the Renaissance, it has been understood that the portrait painter has a duty to reveal the character of his sitters and not merely to copy their likeness. Until comparatively recently this did not mean probing the sitter's inner psychology; it was sufficient if his more salient virtues were displayed. The task presented no theoretical problem, since it was generally believed – following the basic premise of that popular intellectual game of the period, physiognomy – that 'the face is the index to the mind'. In practice, however, the achievement of this aim was very difficult, not so much because of the inherent limitations of the visual medium of painting, although these were serious enough, but because of a fallacy in the theory. Briefly, this fallacy was the assumption that it is possible to *deduce* a person's character by studying his features, whereas in fact his character can only be *recognized* by this means; in other words, the face only reveals character to those who know it already. To friends and contemporaries of the sitter, his portrait may reveal him 'to the life', but its doing so depends on their knowing him in life and being able to read into the portrait his typical expression, aspects of his character and so on, which are already familiar to them. To take a specialized case – one of the few recorded contemporary comments on Rembrandt as a portrait painter: the poet, Vondel, instructed Rembrandt, when portraying Jan Cornelisz Anslo, who was a famous preacher in Amsterdam, 'to paint Cornelisz's voice'. Whether Vondel was satisfied with the result is not known, but Rembrandt's presumed success, even in the metaphorical sense in which Vondel meant it, is inevitably lost on us as we have no means of comparing the painting with the living model. It follows from this that a portrait can convey character to posterity to something like the extent it did to contemporaries only if the sitter is historically very well known; that is to say, if we possess written information about him which we can read into his portrait in the same way that contemporaries were able to apply their knowledge of him gained from life. Unfortunately none of Rembrandt's sitters is historically well known in this sense.

It does not seem that the significance of this aspect of the problem of portraying character found a place in Renaissance and seventeenth-century art theory. Nevertheless, painters appear to have grasped it intuitively from an early date and to have attempted to convey certain elements of a sitter's character by means which posterity could discern. One favourite method was to include symbolic attributes of the sitter's accomplishments or profession; another was the use of emblems; a third was idealization of the sitter's features and body, to emphasize his position in society and distinction of mind. Rembrandt, as might be expected, had a deeper understanding of the problem than any other painter yet he used hardly any of the usual, mostly external, devices. His means were chiefly inward-looking and subjective – above all, the *chiaroscuro*. He used *chiaroscuro* to create an appropriate mood or a revealing play of emotions in the sitter's features. Alternatively, he would emphasize some features at the expense of others; thus in some of his self-portraits he adjusts the shadow down one side of his face to hide the bulbousness of his nose. In this type of self-portrait he presents himself as refined and relaxed, quietly confident of his powers; in other types the thickness of his features is unsparingly revealed and he appears aggressive when young or anguished when old. A further means of expressing character, as it is of achieving variety, is also common in

25

the self-portraits. This is the casting of the figure in some guise or role by the use of costumes, the pose and, occasionally, associations of style. At one extreme this takes the form of dressing up or play acting, as in *Saskia as Flora* (pl. 11). At the other extreme it may appear as a subtle emphasis on one side of a sitter's personality at the expense of others: for example, slight adjustments to the composition and *chiaroscuro* in the portrait of Jacob Trip (fig. 9) tend, without detracting from his individuality, to build him up into 'the man of authority'. In the same way, Rembrandt presents himself in his self-portraits now as 'the artist' (Frontispiece), now as 'the gentleman', and so on.

From all this it is evident that Rembrandt's depiction of character is far from being the total disclosure that it is sometimes made out to be (though it is significant that those who hold this view tend to be reticent as to the precise characteristics disclosed). What Rembrandt achieves is all that a painter can achieve, namely to show, by artistic means, certain qualities of a sitter's character that we might be able to recognize in his face if we knew him in life. It is in the nature of things that we cannot specify or label these qualities very exactly and that our understanding of them is subjective; yet, such is Rembrandt's skill, they can be identified within fairly narrow limits. Beyond these limits, Rembrandt gives us 'character' in a more general sense, as we say in the phrase 'this figure is full of character', or that person is 'a man of character'. He does this by making his figures look within themselves as well as out towards us, and by presenting them in a context of introspection and thought. These qualities will be discussed again in a moment but at this point it will be convenient to look at some examples of Rembrandt's portraiture in slightly more detail. They will be taken in approximate chronological order but the differences between them can be found at all stages of his career and only partly reflect a development in his approach.

The first is the enchanting *Saskia as Flora* in Leningrad (pl. 11) of 1634. This is a costume piece like the well known painting of the same subject in London, but the two are not identical in treatment. In the London *Saskia* we are very much aware of the contrast between the sitter and her costume, although this contrast is itself revealing and not merely awkward. It is a portrait of Saskia unaccustomed to this fancy dress. In the Leningrad painting the sitter, though still clearly recognizable as Saskia, has been more fully assimilated to the idea of a classical goddess. The metamorphosis is not complete and is all the more touching for that, but Saskia's face is sweetened and she steps into her pastoral role with a grace that owes something to Titian and Rubens as well as to contemporary Dutch conventions of pastoral painting. Her pregnancy adds the idea of fertility to the traditional conception of the classical goddess of spring. The handling is smooth and the colours unusually clear and decorative for Rembrandt. Flowers appear in the background as well as in Saskia's hair and wound round her staff. The gesture of holding something lightly in the hand, as so often in Rembrandt, is an indication of informality; cf. Jan Six drawing on his gloves (colour plate in text) or Titus puzzling over his homework (pl. 31). The picture sustains, fused and in perfect balance, a number of contrasting associations: those of reality, mythology and the stage. Is the figure Saskia dressed up as Flora, or an allegorical painting of Flora for which Saskia sat as a model? That the answer is in doubt is an index of the painting's position on the borderline between portraiture and mythology. It is at once a personal record of Rembrandt's affection for his wife – and hence it tells us something about one side of her personality – and a commentary on the pastoral convention of spring. Yet despite this interplay of ideas, it is completely lucid and unified as a work of art.

There is no fanciful costume or symbolism in the portrait of *Adriaentje Hollaer* (pl. 21), but in its quiet way this is an almost equally remarkable work. The sitter was the wife

of a minor Dutch *genre* painter active in Rotterdam, Hendrick Sorgh (pl. 20). She is seen half-length, with her hands demurely folded and a shy smile on her face. She glances towards her husband who is represented in the other portrait, the two paintings forming a pair in visual relationship to one another, as in Frans Hals. She is a homely body with apple-like cheeks; she has charm but no glamour. A fine veil of atmosphere hovers over her features, emphasizing the roundness of her head, cap and ruff. These forms echo and extend one another both on the surface of the picture and in depth. Like the hands, they are painted almost in isolation from the body or any other solid object and are silhouetted against a very dark background. In most respects the figure is the quintessence of the ordinary, and in this lies the painting's idea. Adriaentje Hollaer might be the real-life counterpart, slightly older and with all the minute irregularities of the natural woman left in, of the Madonna in the *Holy Family with Angels*. Just as domesticity is raised in that work to a high poetic and spiritual level, so, in this portrait, it is celebrated in terms of everyday reality.

In the late portrait of *Gérard de Lairesse* (pl. 45), the style considered as an end in itself seems to take over the face. We are scarcely aware of character, despite the fact that this not very intelligent painter, who later wrote a treatise on art theory, is one of Rembrandt's few sitters whose personality is fairly well known to us on the evidence of his own writings (these were, however, composed much later). The chief interest of the portrait lies in the beauty of the handling and the pattern of highlights and angular shapes which interlock like the pieces of a *collage* throughout the composition. The treatment of *Jacob Trip* (fig. 9) is very different. Here, every stroke proclaims the idea of authority – the parallel verticals of the stick and the chair, the severely upright pose, the look in the heavy-lidded eyes, and the shadows which fall in such a way as apparently to lengthen the face. It happens that several other portraits of Trip by different artists are known, from which it can be seen that Rembrandt's is a good likeness. But the comparison also shows that it is very much more than a likeness. The versions by Cuyp and Maes tell us little more than that the sitter was an old man with a thin face and hooked nose. Rembrandt depicts the aged armaments manufacturer as a symbol of iron will power. No Old Testament prophet or mythological sage in his *oeuvre* is as gaunt as this formidable ancient figure, who is both sinister and wise, a merchant patriarch of the new, Protestant Jerusalem which was Amsterdam. Even if the sitter's whole personality cannot be understood and if the presentation is one-sided, even though any interpretation is bound to be subjective – even though these things are true, there is no doubt that this is an image of 'character'. And it is achieved by aesthetic means: by the low viewpoint and imposing breadth of the lower part of the figure, by the massive cloak and archaic, throne-like chair, and, most subtly, by the *chiaroscuro*. This elongates the face and figure, widens the forehead and enlarges the eyes.

'*The Falconer*' (pl. 41) is an equally impressive but more ambiguous work, at once tragic and flamboyant. Is it an imaginary historical portrait? a portrait of a character in a play? a painting of a model in invented clothes? Certainly it has a strange air of unreality: the horse, the groom, the bird – none of these look as if painted from life. Rembrandt seems here to bring back the baroque or Venetian fancy picture in a new guise. The powerful face is pictorially integrated with the rest of the composition yet appears psychologically detached from it. The large eyes are the focus of the picture yet register a blank stare. The brushwork, like the conception as a whole, is broad and vigorous and comparatively unbroken for the late date. The colour – hot red, orange and gold throughout – plays a more independent role than in earlier works and establishes the painting's mood. The model is one who appears frequently in Rembrandt's art around 1660 in a number of

different guises – as Christ, as an apostle or as an un-named bearded man. It is characteristic that his features and age should be varied in each of these representations. Rembrandt's ability to paint from the life and yet alter what he sees is often overlooked by those who try to interpret his portraits and studies of single figures too literally. This is particularly true of his use of his mistress, Hendrickje, as a model. The question, when confronted with a painting of a young or young-ish woman, 'is it Hendrickje?', often does not admit of a yes or no answer.

On the whole Rembrandt is less concerned with old age, or at least with the frailty of old age, in his last works than in those of his middle period. The late figures (including Trip) have an unsentimental toughness underlying the overall tragic mood. This is very evident in his late self-portraits. The late 'forties and early 'fifties were the period of greatest pathos, sometimes bordering on sentimentality. The mood of *An Old Man seated in an Armchair* of 1652 (fig. 30) is in the strict sense of the word 'pathetic', although it is not sentimental. Unlike *'The Falconer'* (which is ambiguous), this picture is clearly not a portrait; but nor is it a mere figure study. The model is dressed in a fur-lined robe reminiscent of a Venetian senator's gown, and the handling and colour are also to an extent Venetian. As a result the painting takes on a poetic quality obtained from the borrowed idiom. It cannot be a commissioned work (whereas *'The Falconer'* may be) and is one of Rembrandt's first paintings to show the broken colours and brushwork of his late style. The various reds, orange-browns and yellows merge into each other with a new fluidity and freedom, while the technique ranges from the relatively finished, subtle glazing used for the head and right hand to the broad, almost crude brushstrokes defining the left hand grasping the chair-arm. The treatment of these two passages is so different that at first glance this hand and the turned back sleeve, which receive the strongest light in the composition, seem unfinished; yet examination of the painting of the robe in between shows no sign of a break. Rembrandt's style is flexible enough by this stage to encompass these variations without destroying the unity of the composition. Seen from the viewpoint of the nineteenth century, this painting seems redolent of content; it evokes a mood and includes overtones of an idea. But by seventeenth-century standards it is informal and lacking in subject. We interpret it as both a pictorial study of an old man and a poetic image of contemplation and the weariness of old age.

Contemplation or introspection is the *leitmotiv* of Rembrandt's mature and late portraits. Sunk in reverie or gazing towards the observer, the figures seem to exist in an atmosphere of their own. They are watchful yet withdrawn, and behind the eyes the mind is preoccupied by thought. Rembrandt began treating portraits and studies of old people in this way very early in his career, then applied the same method to his self-portraits, and finally extended it to all his portraits in varying degrees after 1640. As a conception of portraiture this was not without precedents: the *Mona Lisa* is one famous example and there are others of a slightly different kind in the work of Titian. But Rembrandt developed this type of portrait further than anyone else and used it for a far wider range of sitters. Although its most typical representatives are men accustomed to thought rather than action – doctors, preachers and artists – it is not confined to them.

Rembrandt's principal means is once more the *chiaroscuro*. The face normally receives the strongest light, which gives it the prominence which its importance in the portrait leads one to expect. At the same time the face is criss-crossed by shadows which both lend it interest and character and enmesh it, as it were, in the background. Shadows collect in and around the eyes and the hollows of the cheeks, down one side of the nose and round the mouth. Sometimes the eyes are heavily shaded by a hat. The edges where one tone meets another are softened, and it is frequently the side of the face turned to-

wards the observer which is illuminated, thereby avoiding a sharply silhouetted cheek-line on the other side. The effect of all this is to divert attention from the face as a unit and transfer it to the features. The features, especially the eyes, thus become all the more telling as indicators of mood and character. Yet for all their rich expressiveness they remain partly inscrutable, for two reasons. The first reason is that the eyes are defined by the shadows, not by the light, which gives them a far-away look, as if there were some invisible force uniting them with the background (it is remarkable how much more aggressive – and less interesting – the faces in Rembrandt's portraits appear if they are looked at with the backgrounds masked off). The second reason is that the expressions are not superficially animated. Rembrandt's sitters may watch the observer intently; they do not communicate with him. Their eyes are steady and their mouths closed. Animation lies in the technique – the fluid *impasto*, the delicate and varied glazing, the play of atmosphere and light and shade over the features; it does not lie in the features themselves.

This is a conception of portraiture that belongs at the opposite pole from arrested movement; the impression is rather one of immobility and timelessness. It follows that Rembrandt's portraits stand not just for the likeness and characterization of individuals. Nor do they add up to 'the portrait of an epoch'; they are not social documents. While each portrait is unique and each records the lineaments of a particular person, it carries overtones which make the individual the representative of suffering humanity. At bottom what Rembrandt portrays is the human predicament. And he saw that predicament as both tragic and watched over by a mysterious spiritual force. It is not for nothing that critics have seen a resemblance between Rembrandt's paintings and the philosophical ideas of his fellow resident of Amsterdam, Spinoza (although the latter was too young to have influenced him). Both men were steeped in the Jewish scriptures, and Rembrandt would have shared Spinoza's doctrine of the integration of spirit and matter. The mystery which permeates Rembrandt's shadows is ultimately a metaphor of the immanence of God.

There is one further characteristic of Rembrandt's portraiture: the intensity of the relationship between the sitter and the observer. Although in one sense Rembrandt's sitters are remote from us, in another sense they are vividly real. They are vulnerable to scrutiny and, wearing no social mask, they draw us into their world. The experience of looking at them is essentially private; it excludes the presence of a third person and exposes the observer to his own thoughts and feelings as much as it reveals those of the person portrayed (contrast Frans Hals, whose sitters often seem to be looking over the observer's shoulder at someone else). There is some reason to believe that Rembrandt always wanted his paintings to be contemplated very intimately. He interposed first the background, then the frame, as a barrier between the painted image and the outside world – this was the reverse of the baroque principle of extending the created world of the painting into the observer's space. In two cases, not portraits (cf. note to pl. 38), Rembrandt indicated the type of frame he would like: it was a kind of tabernacle, with pilasters either side, a 'base' and a curved or pedimented top. This would have enclosed the work of art as if in a shrine.

To be exact, the contemplation of Rembrandt's portraits usually involves three people: the sitter, the observer and the artist. But there was one category in which this number was reduced to two: the self-portraits. Perhaps it is not altogether fanciful to see this factor as an additional, aesthetic reason, over and above the personal and autobiographical ones, for the quantity of self-portraits in Rembrandt's *oeuvre*. In the self-portrait he was able to address the observer directly, without the distraction of another

personality. If a portrait becomes a work of art as the result of a collaboration between the sitter and the artist, the collaboration is made easier when sitter and artist are one. When painting himself Rembrandt was freer to vary his interpretation by adopting a wider range of poses, costumes and lighting effects than he could use in his commissioned portraits; he could treat himself as either sitter or model, that is, he could depict himself either more or less realistically; and, knowing himself better than he knew anyone else, he could make the self-portrait a more effective vehicle of character. He was sufficiently self-absorbed to represent his own features at least twice a year throughout his working life; and he did so for the most part not in the casual or experimental media of drawings and oil sketches but in finished paintings and, to a less extent, etchings. Many of these painted self-portraits are as highly wrought as any portraits in his *oeuvre*. It is not impossible that there was a market for them (significantly, not one is listed in his inventory of 1656, although many of his other paintings and oil sketches appear there). If Rembrandt's self-portraits constitute a diary, as in a sense they do, it was a diary at least partly intended for publication.

Nevertheless, his self-absorption was accompanied by a remarkable objectivity. In his youth he was bold enough not to disguise his conceit; in his maturity and old age he became his own severest critic. To call Rembrandt's self-portraits his greatest achievement would be to fall into the trap of sentimentalizing him. It would also be incorrect. But they are in some ways the purest expression of his approach to portraiture.

# A NOTE ON THE LANDSCAPES

As we have seen, Rembrandt was not a *genre* painter, although he made many drawings of *genre* scenes from life. It would be impossible to deny that he was a landscape painter, but the same distinction applies; that is, he made numerous landscape drawings from nature but very few landscape paintings of this type. Apart from these exceptions, all his landscape paintings were imaginary, and they were all executed, including the few naturalistic ones (pl. 24B), during his middle period, between about 1636 and 1655. As with his treatment of *genre*, the gap between drawings and paintings was bridged by the etchings, which are partly naturalistic and partly verging on the imaginary.

Objectively it is hard to understand the gulf between the two categories. As a landscape draughtsman from nature, Rembrandt was one of the most brilliant and inventive of all artists; light and air vibrate between every stroke of his rapid sketches of the open Dutch countryside (fig. 4). His paintings, on the other hand, are motionless and claustrophobic, despite their romantic intensity (pl. 13). To a greater extent than any of Rembrandt's other works they fall into a category of their own in the history of art. Whereas his subject pictures, painted figure studies and portraits entered the mainstream of later European painting, his landscape paintings have had only an occasional influence (for example, on English watercolours around 1800). Rembrandt's landscapes seem to deny one of the basic principles of the art: interest in the mutually supporting roles of space, light and air. Instead, these elements tend to contradict one another in his work. While the arbitrary relationship between the light and shade pattern and the composition is an effective source of visual surprise, it prevents the landscape from expanding outwards to the sides or backwards into depth as far as the horizon. The exceptions to this tendency prove the rule, for they occur not in his imaginary landscapes proper but in the background of a figure painting – the '*Noli me tangere*' (pl. 24A) – or in the naturalistic *Winter Landscape* (pl. 24B). These at least are beautifully fresh.

Yet Rembrandt's landscape paintings may become more intelligible if they are seen in

the context of his own aesthetic attitudes. Like his ideas of architecture and costume, he evolved his conception of landscape independently of the classical tradition, that is, independently of the conventions of ideal landscape painting. Rembrandt's antiquity is an imaginary Hebraic antiquity (derived if anything from Turkish sources), developed as an alternative to the Greek and Roman antiquity of Italian and Italianising artists. Almost the only thing his landscapes have in common with ideal landscapes is that they are not naturalistic. But unlike ideal landscapes, and unlike the landscapes of that other great Northern inventor of imaginary scenes – Rubens – Rembrandt's landscape paintings have no real basis in the study of nature. Nor, unlike his drawings, are they Dutch in topography, although they show some Dutch stylistic influences. As was the case with his treatment of *genre* scenes, he transposed the subject matter of his landscapes – nature – onto the plane of religious art. They have that brooding, numinous quality which informs so much of his work. They confirm once more, if only negatively, that the true subject of Rembrandt's art is man.

# Outline biography

**1606** Rembrandt Harmensz van Rijn born on 15 July at Leyden, the son of Harmen Gerritsz van Rijn, miller, and Neeltgen Willemsdochter van Zuidbroeck, daughter of a baker. He was the last but one in a family of five boys and two girls.

**1620** 20 May: Rembrandt's name appears on the roll of Leyden University. His stay there, which was short, was presumably preceded by about 7 years spent in the Latin School at Leyden.

**1620–24** Period of apprenticeship: three years with Jacob Isaaksz van Swanenburgh in Leyden; six months with Pieter Lastman in Amsterdam; perhaps also a short time with Jacob Pynas (Houbraken, 1718; the apprenticeship with Lastman, which was by the far the most important, also mentioned by Sandrart, 1675).

**1625** Rembrandt returns to Leyden and sets up as an independent painter, sharing a studio with Jan Lievens (1607–74), a former pupil of Lastman. The association between the two painters probably lasted until c. 1629/30.

**1628** February: Gerard Dou (1613–75) becomes Rembrandt's first pupil, remaining with him perhaps until 1631/2.

**1630** Death of Rembrandt's father.

**1631/32** Between 8 March 1631 and 26 July 1632, Rembrandt settles permanently in Amsterdam, lodging first with the dealer, Hendrik van Uylenburgh, in the Breestraat.

**1633** 5 June: betrothal to Saskia van Uylenburgh (1612–42), the daughter of a former burgomaster of Leeuwarden and a cousin of Hendrik van Uylenburgh.

**1634** 22 June: marriage to Saskia at Sint-Annaparochie, near Leeuwarden.

**1635** 15 December: baptism of Rembrandt and Saskia's first child, Rumbartus (buried 15 February 1636).

**1636** February: Rembrandt is living in the Nieuwe Doelenstraat.

**1638** 22 July: baptism of second child, Cornelia, called Cornelia I (buried 13 August 1638).

**1639** 12 January: Rembrandt is living in the Sugar Refinery on the Binnen Amstel. On 1 May he moves into a grand house, for which he was unable to pay, in the Breestraat.

**1640** 29 July: baptism of third child, called Cornelia II (buried 12 August 1640). On 14 September, Rembrandt's mother is buried in St Peter's Church, Leyden.

**1641** 22 September: baptism of fourth and only surviving child of Rembrandt and Saskia – Titus.

**1642** 14 June: death of Saskia (buried five days later in the Oude Kerk, Amsterdam).

**1649** 1 October: first reference to Hendrickje Stoffels (c. 1625–63) as living in Rembrandt's household. She remained with him until her death.

**1654** 25 June–23 July: Hendrickje summoned four times before the Council of the Reformed Church and admonished for living in sin with Rembrandt. 30 October: baptism of Hendrickje's child, Cornelia.

**1656** 17 May: Rembrandt transfers the legal ownership of his house to Titus. 25 and 26 July: Inventory of the contents of the house in the Breestraat drawn up by the Court of Insolvency. His appeal for the liquidation of his property, to avoid being declared a bankrupt, had been agreed shortly before.

**1657** December: first sale of Rembrandt's possessions.

**1658** 1 February: the house in the Breestraat auctioned for 11,218 guilders (nearly 2,000 guilders less than Rembrandt had paid in 1639), although for legal reasons Rembrandt probably continued to live there until 1660. 14 February: further sale of possessions authorized. 24 September: final sale authorized of remaining prints and drawings in Rembrandt's collection, including many of his own (total, 600 guilders).

**1660** Rembrandt moves to a smaller house in the Rozengracht. Owing to a recent decree of the Guild of St Luke, Rembrandt, as an insolvent, was no longer allowed to sell his works or deal in other works of art in his own name. Titus and Hendrickje form a company for dealing in works of art, with Rembrandt as their employee.

**1663** 24 July: burial of Hendrickje Stoffels in the Westerkerk.

**1668** 10 February: marriage of Titus to Magdalena van Loo. On 7 September Titus is buried in the Westerkerk. A daughter, Titia, is born to Magdalena and baptised on 22 March 1669.

**1669** 4 October: Rembrandt dies in the house in the Rozengracht. He is buried in the Westerkerk, Amsterdam, on 8 October.

BIBLIOGRAPHY

K. **Bauch**, *Rembrandt: Gemälde*, Berlin, 1966 (abbr: Bauch).

O. **Benesch**, *The Drawings of Rembrandt*, 6 vols., London, 1954–57 (abbr: Ben.).

O. **Benesch**, *Rembrandt as a Draughtsman*, London, 1960.

W. **Bode**, *Great Masters of Dutch and Flemish Painting* (English edition), London, 1909.

A. **Bredius**, *Rembrandt*, revised by H. Gerson, London, 1969 (abbr: Br.).

K. **Clark**, *Rembrandt and the Italian Renaissance*, London, 1966.

H. **Focillon** and L. **Goldscheider**, *Rembrandt*, London, 1960.

H. **Gerson**, *Seven Letters by Rembrandt*, The Hague, 1961.

C. **Hofstede de Groot**, *Die Urkunden über Rembrandt* (1575–1721), The Hague, 1906.

N. **Maclaren**, *National Gallery Catalogues: The Dutch School*, London, 1960 (abbr: *National Gallery Catalogue*).

L. **Münz**, *Rembrandt's Etchings*, London, 1952 (abbr: Münz).

J. **Rosenberg**, *Rembrandt, Life and Work*, 2nd ed., London, 1964.

J. **Rosenberg**, S. **Slive** and E. H. **ter Kuile**, *Dutch Art and Architecture* (Pelican History of Art), Harmondsworth, 1966.

S. **Slive**, *Rembrandt and his Critics*, The Hague, 1953.

W. R. **Valentiner**, *Rembrandts Gemälde* (Klassiker der Kunst), Stuttgart and Leipzig, 1908 (abbr: K d K).

C. **White**, *Rembrandt and his World*, London, 1964.

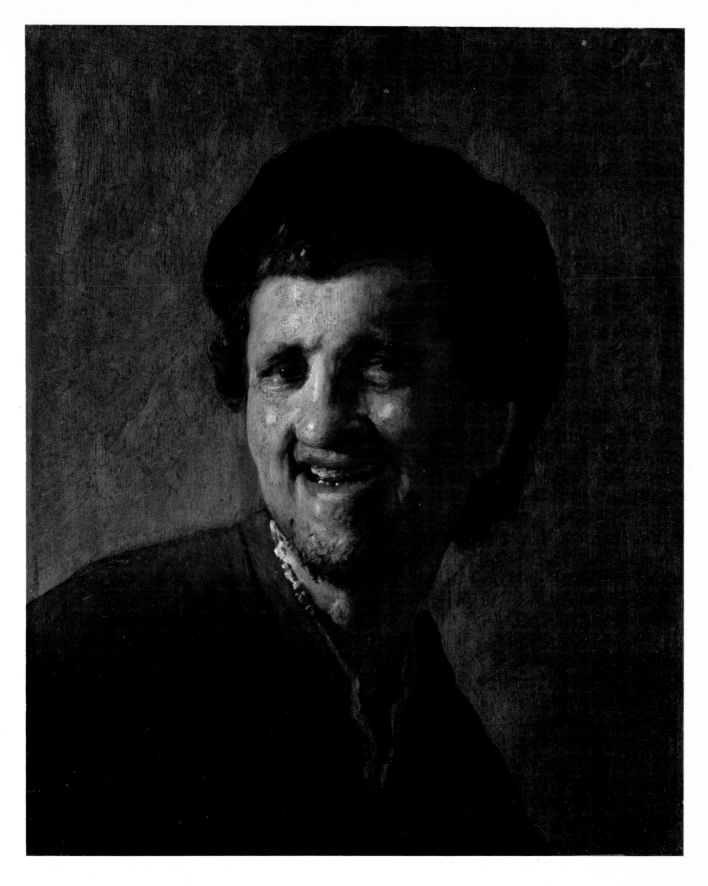

1. SELF-PORTRAIT. Amsterdam, Rijksmuseum

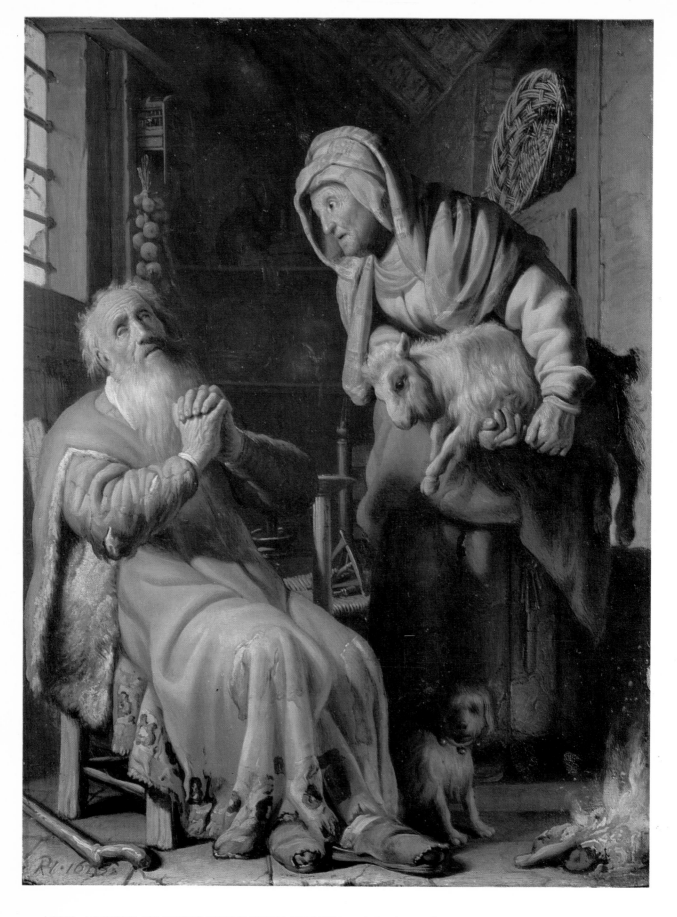

2. ANNA ACCUSED BY TOBIT OF STEALING THE KID. 1626. Amsterdam, Rijksmuseum (on loan from Baroness Bentinck-Thyssen)

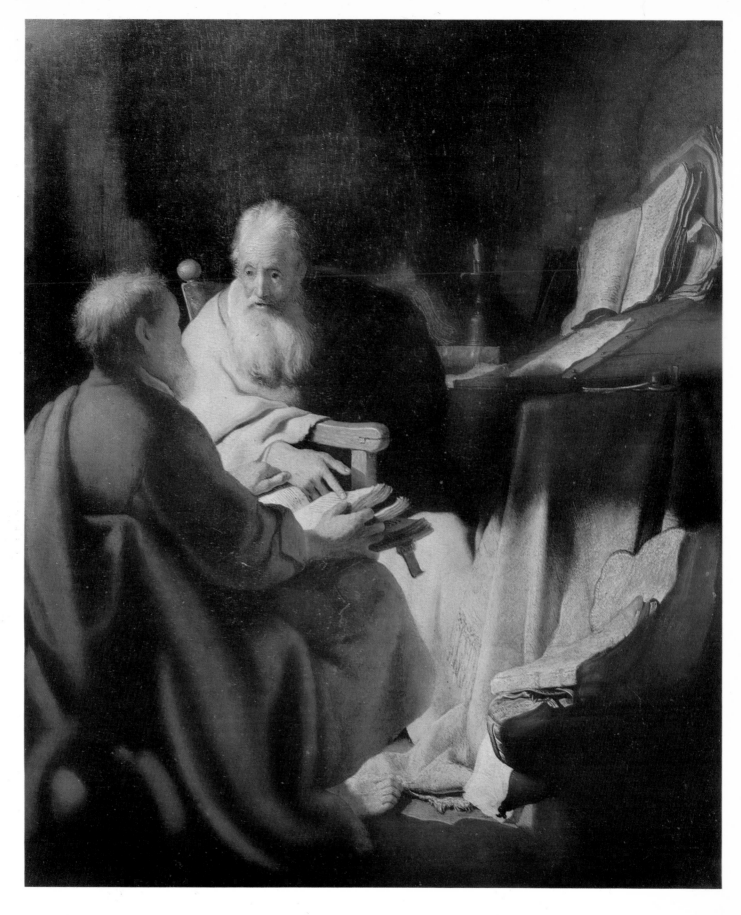

3. TWO SCHOLARS DISPUTING. 1628. Melbourne, National Gallery of Victoria

4. REMBRANDT'S MOTHER (?). Windsor Castle (reproduced by Gracious Permission of H.M. the Queen)

5. AN OFFICER. London, Sir Brian Mountain

6. AN ARTIST IN HIS STUDIO. Boston, Museum of Fine Arts

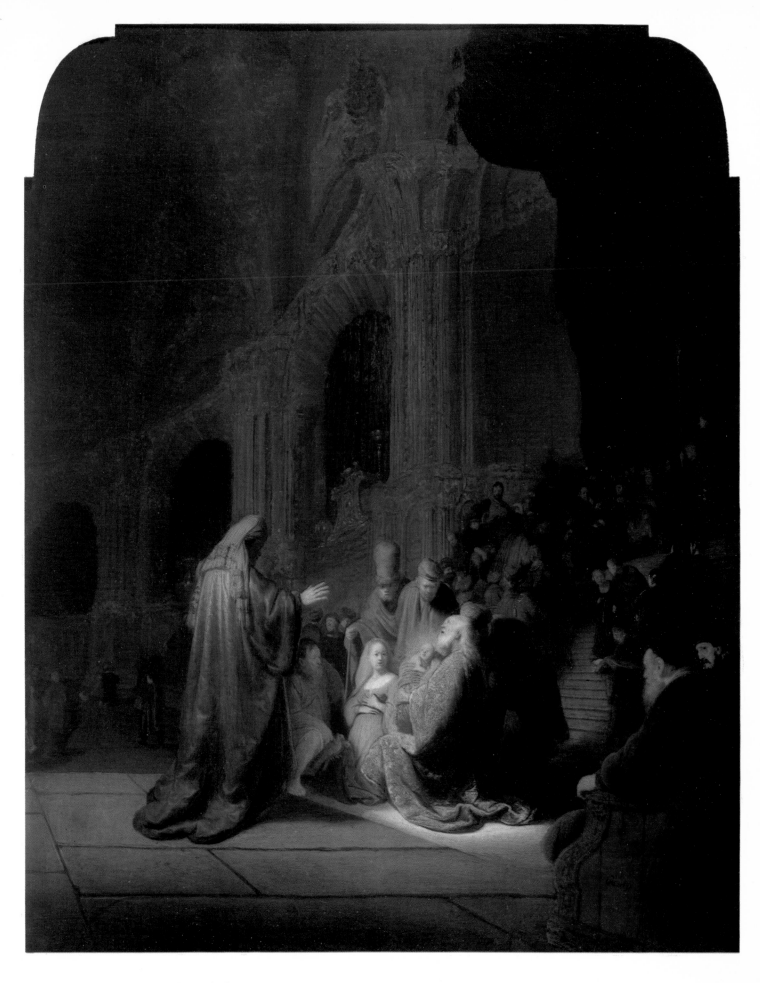

7.  THE PRESENTATION OF JESUS IN THE TEMPLE.  1631.  The Hague, Mauritshuis

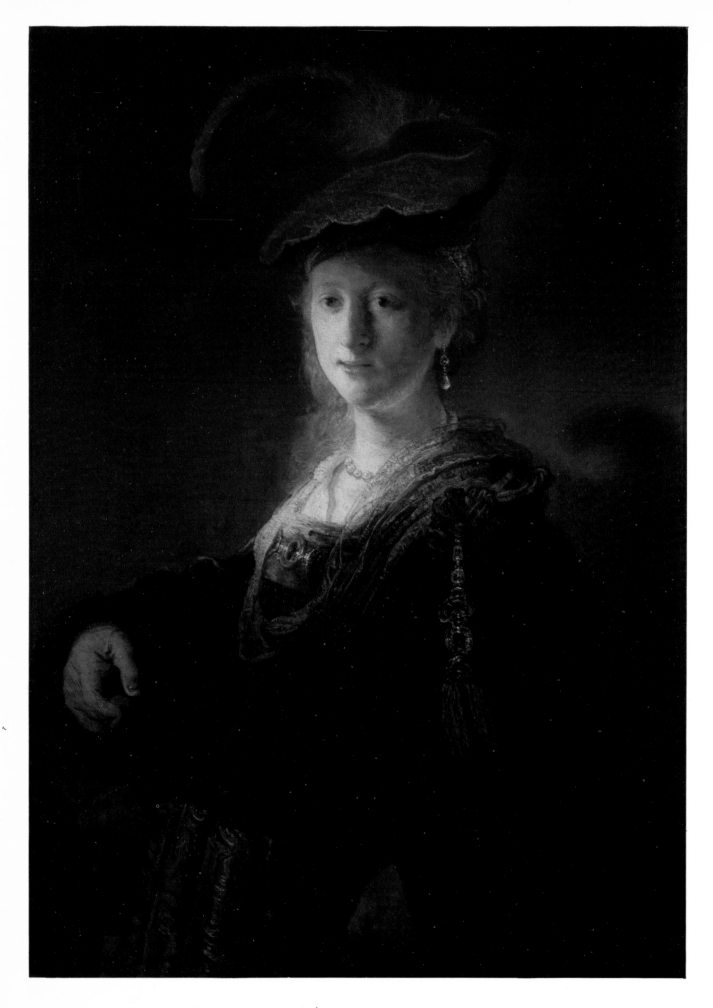

10.   A YOUNG WOMAN IN FANCY DRESS.   163(5?).   Château de Pregny (Geneva), Baron Edmond de Rothschild

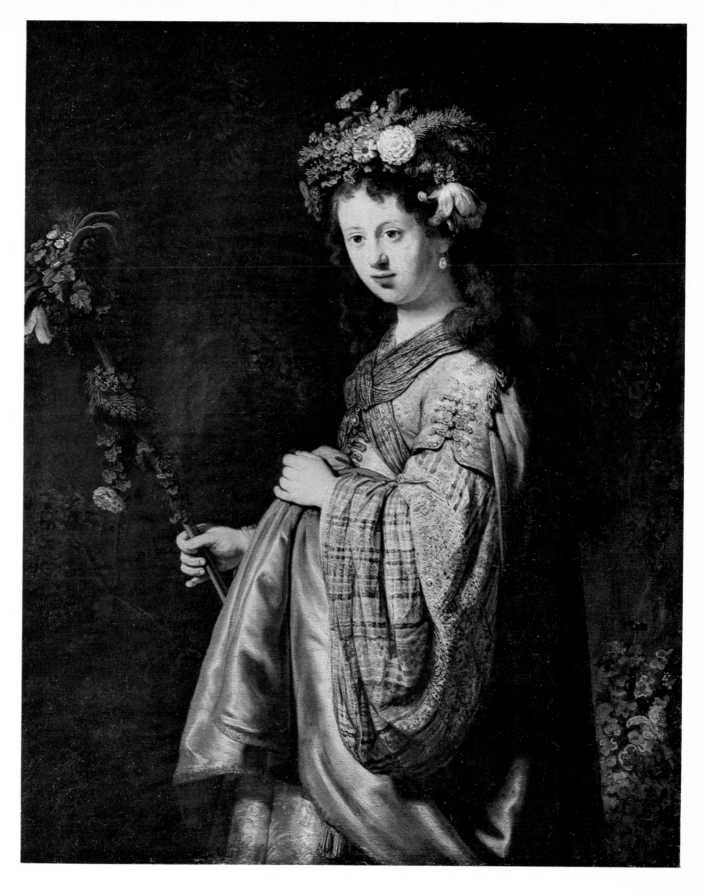

11.  SASKIA AS FLORA.  1634.  Leningrad, Hermitage

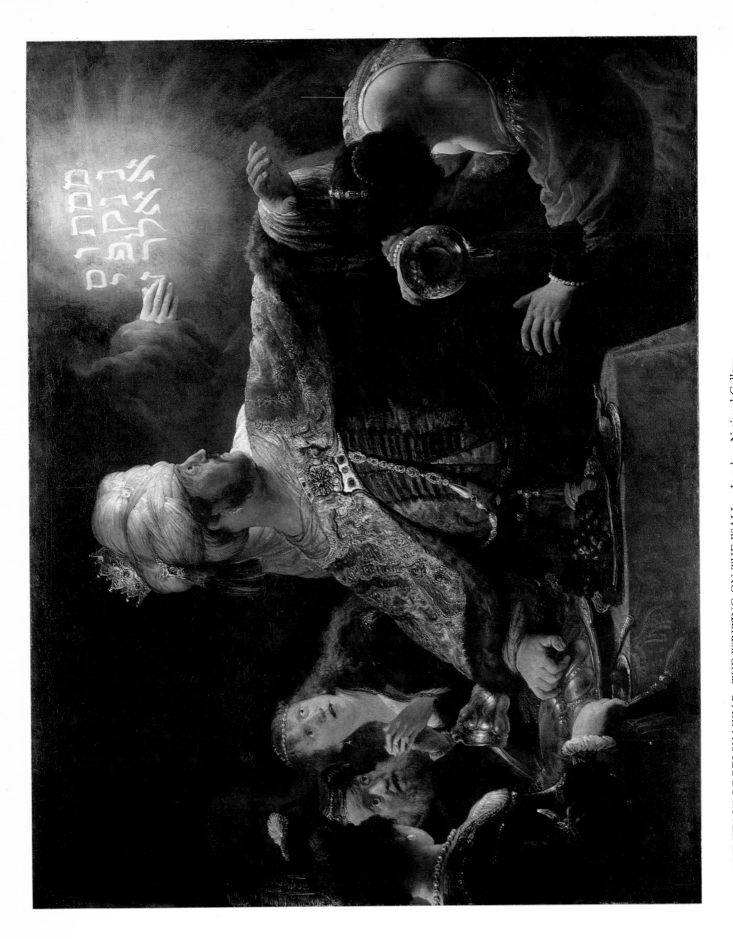

12.  THE FEAST OF BELSHAZZAR: THE WRITING ON THE WALL.   London, National Gallery

13. LANDSCAPE WITH A CHURCH. Madrid, Duke of Berwick and Alba

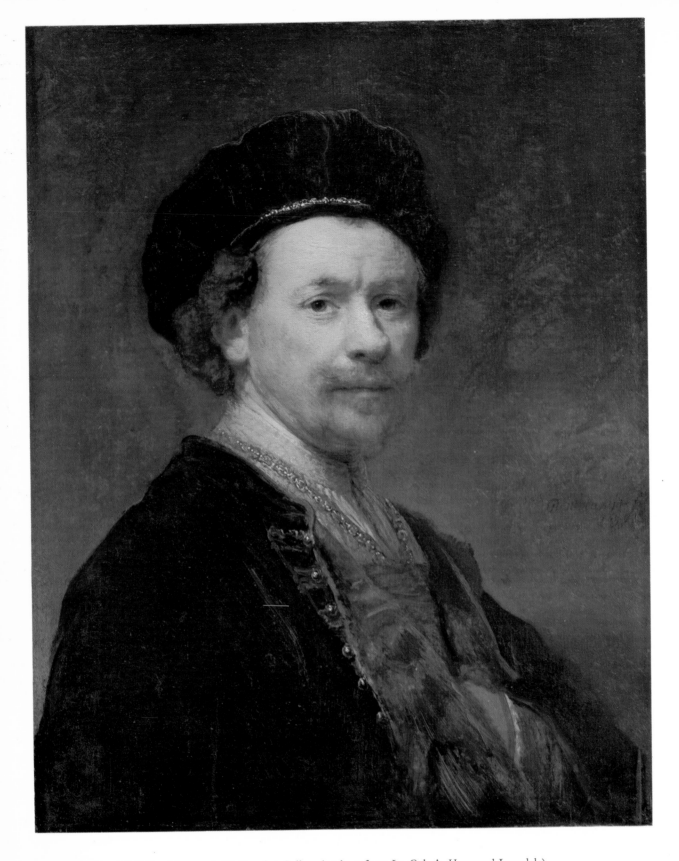

14. SELF-PORTRAIT. Liverpool, Walker Art Gallery (on loan from Lt.-Col. A. Heywood-Lonsdale)

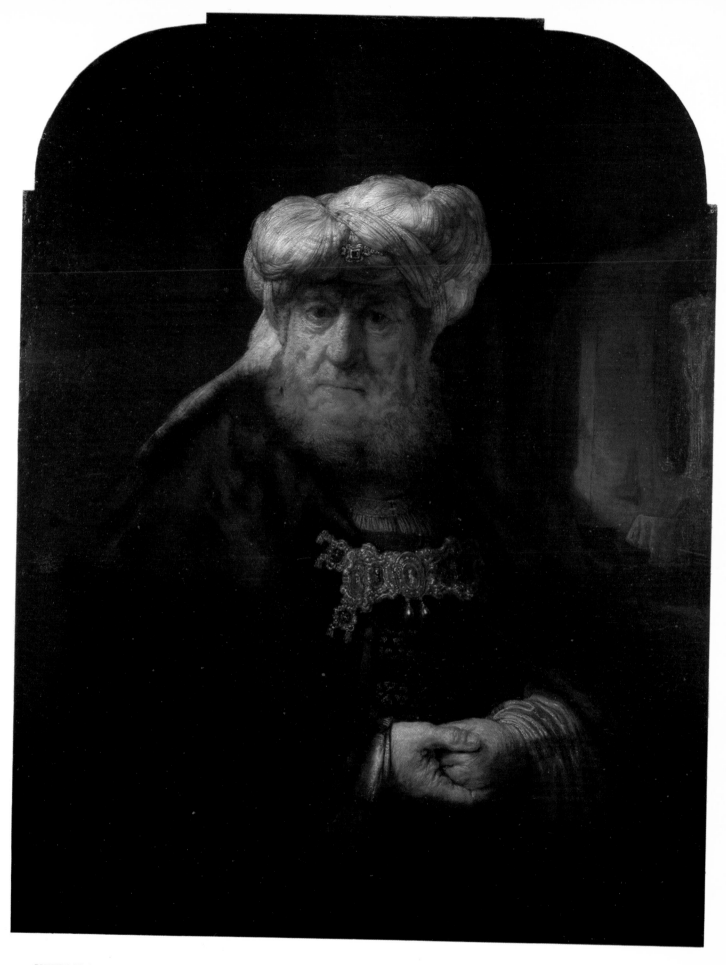

15. UZZIAH STRICKEN WITH LEPROSY (?). 1635. Chatsworth, Derbyshire, The Trustees of the Chatsworth Settlement

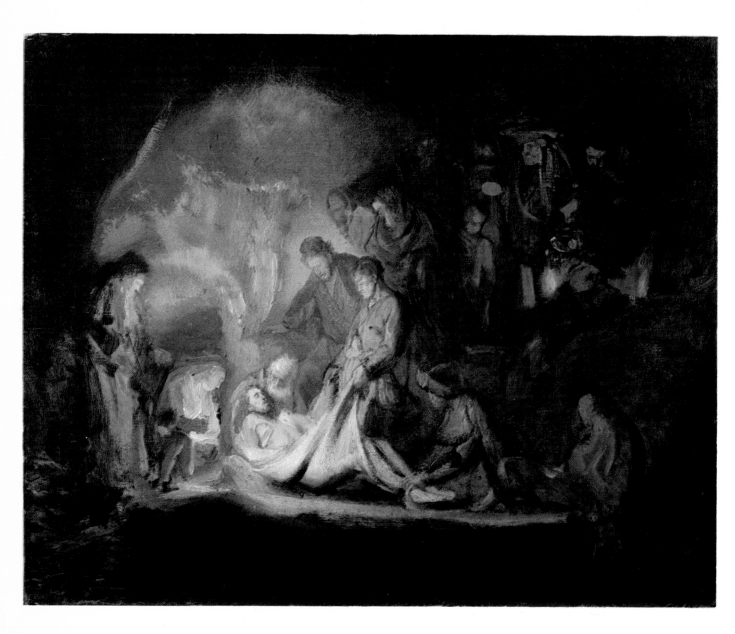

18.  THE ENTOMBMENT OF CHRIST.  Glasgow University, Hunterian Museum

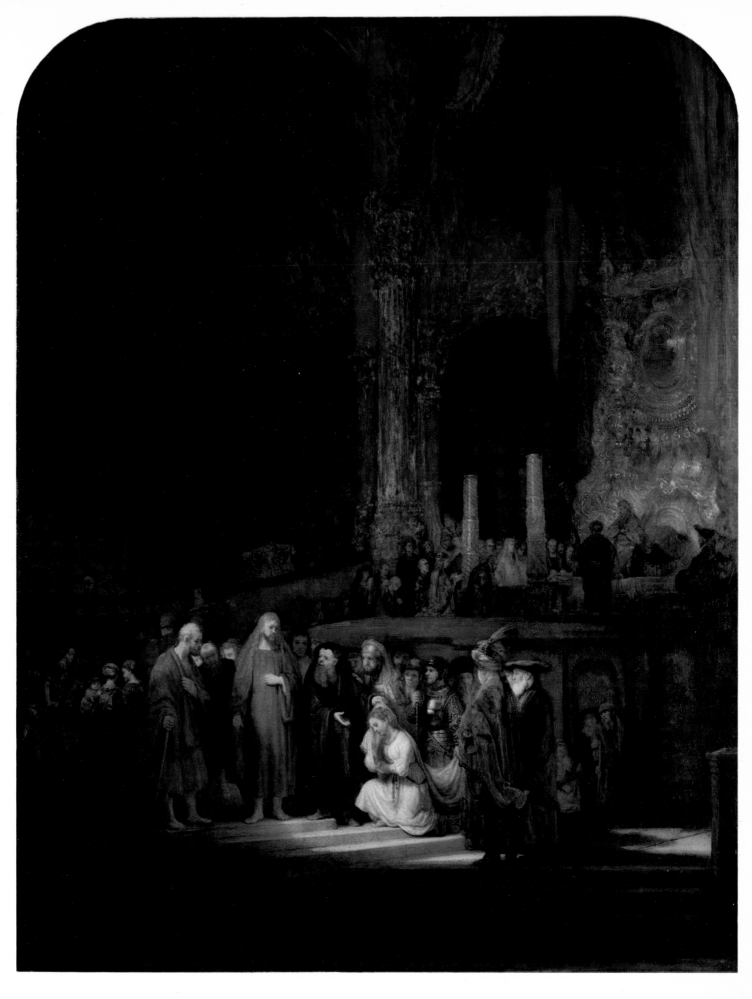

19.  CHRIST AND THE WOMAN TAKEN IN ADULTERY.  1644.  London, National Gallery

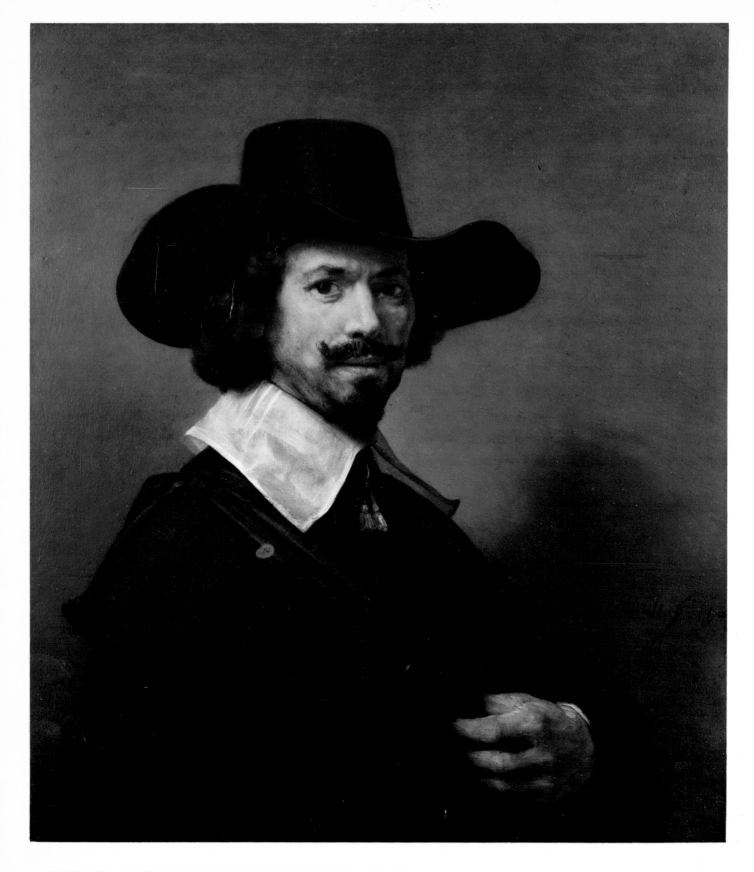

20. PORTRAIT OF THE PAINTER HENDRICK MARTENSZ. SORGH. 1647. London, the Trustees of the 2nd Duke of Westminster and Anne, Duchess of Westminster

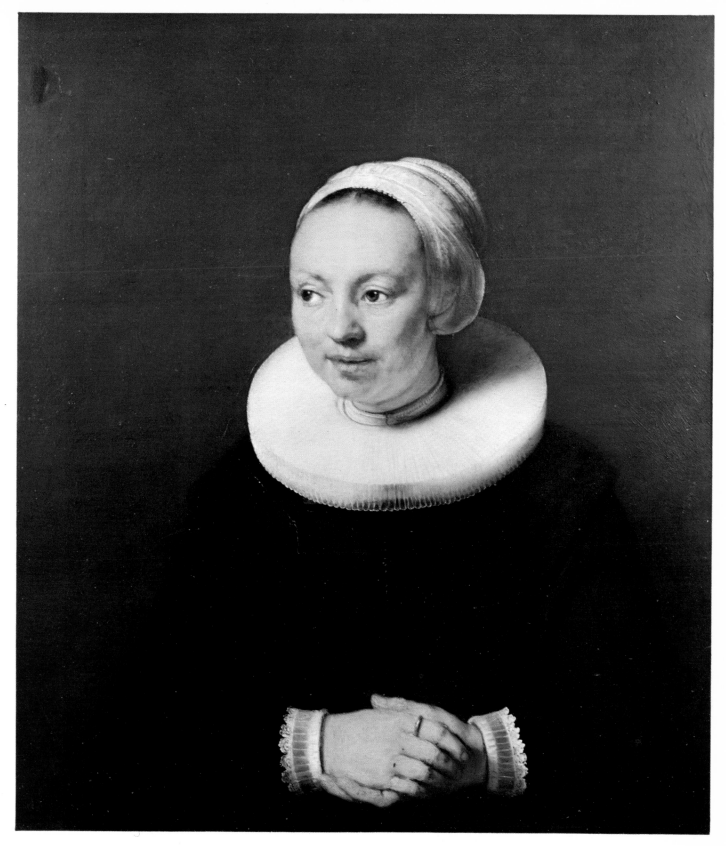

21. PORTRAIT OF ADRIAENTJE HOLLAER, WIFE OF HENDRICK MARTENSZ. SORGH. 1647. London, the Trustees of the 2nd Duke of Westminster and Anne, Duchess of Westminster

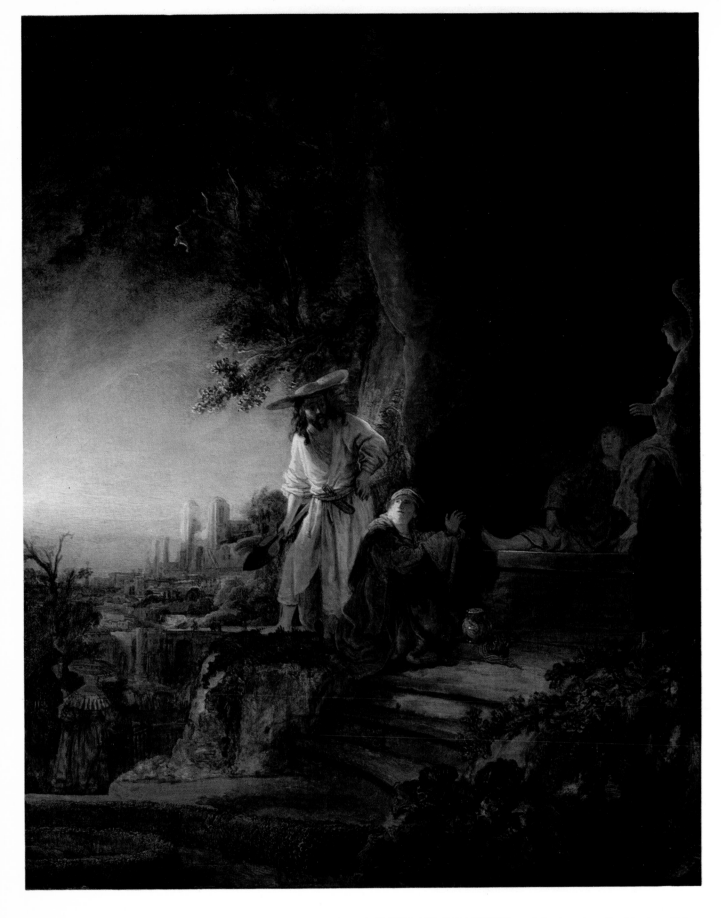

22. THE RISEN CHRIST APPEARING TO THE MAGDALEN ("NOLI ME TANGERE"). 1638. London, Buckingham Palace
(reproduced by Gracious Permission of H.M. the Queen)

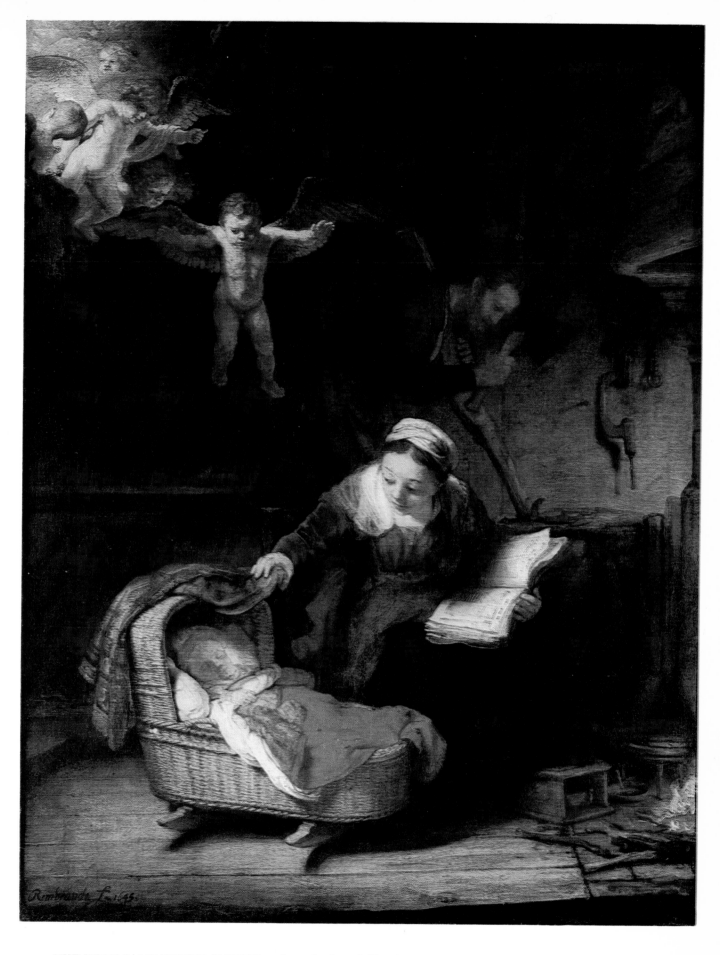

23. THE HOLY FAMILY WITH ANGELS. 1645. Leningrad, Hermitage

24A.  Detail of the Landscape from "THE RISEN CHRIST APPEARING TO THE MAGDALEN" reproduced as Plate 22

24B.  WINTER LANDSCAPE.  1646.  Cassel, Gemäldegalerie

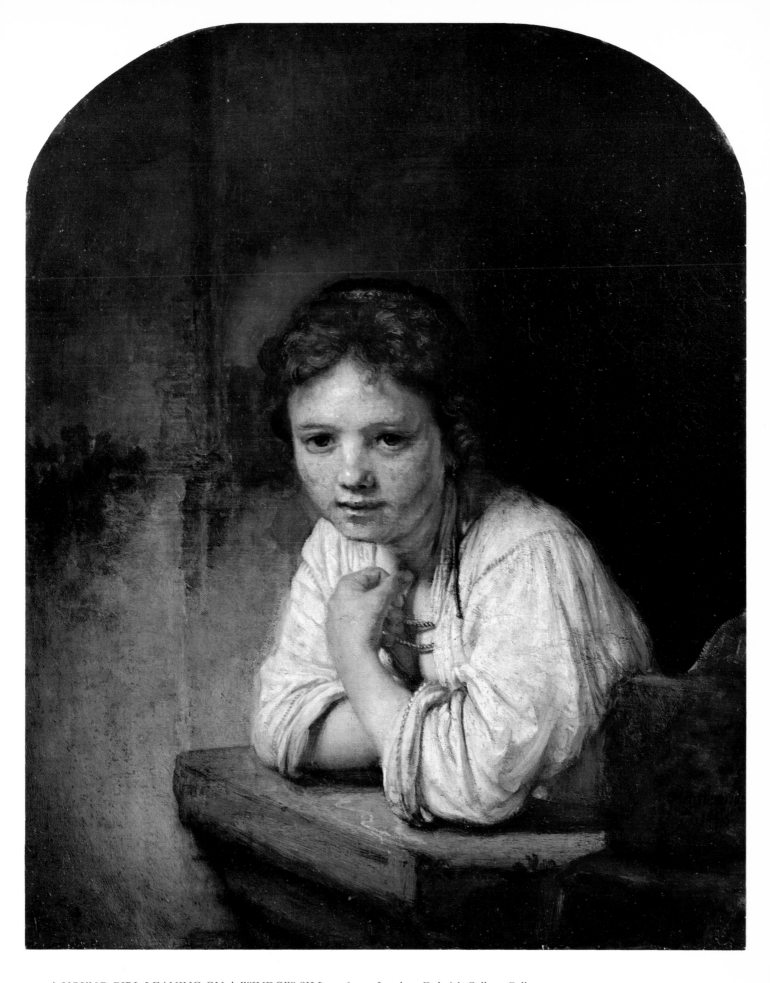

25.  A YOUNG GIRL LEANING ON A WINDOW SILL.  1645.  London, Dulwich College Gallery

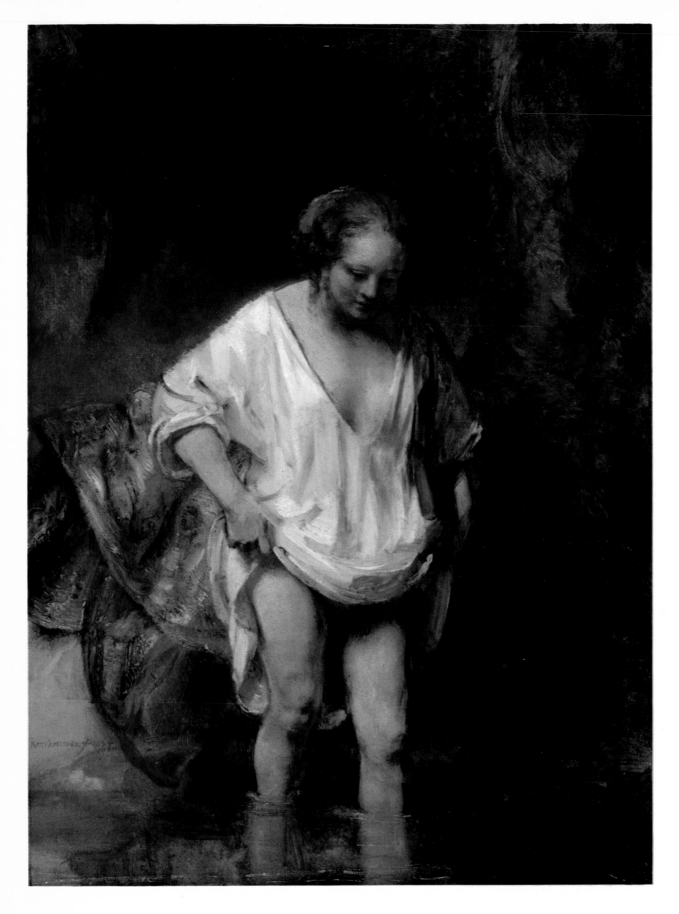

26.  A WOMAN BATHING (Hendrickje Stoffels?).  165(4?).  London, National Gallery

27. HEAD OF CHRIST. Berlin-Dahlem, Gemäldegalerie

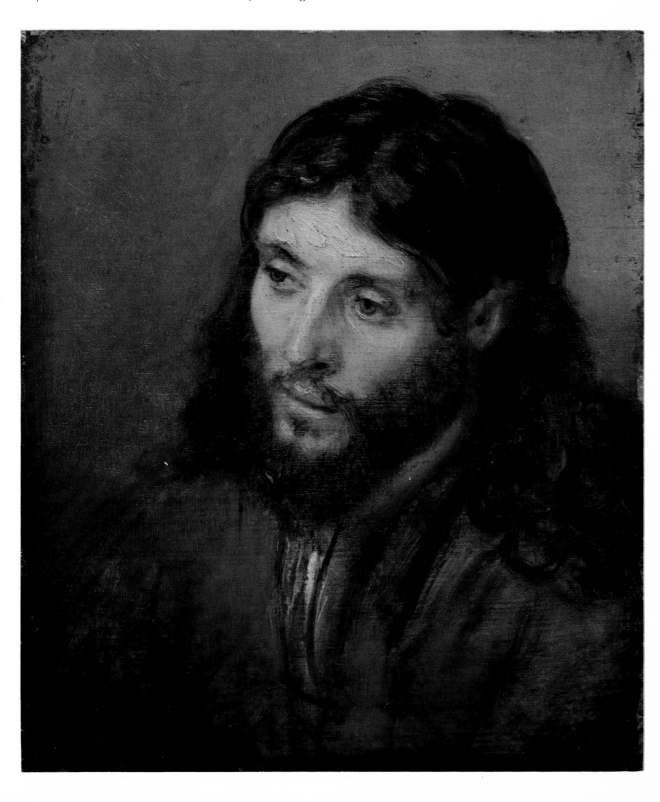

28. THE VISION OF DANIEL. Berlin-Dahlem, Gemäldegalerie

30. AN OLD MAN SEATED IN AN ARMCHAIR. 1652. London, National Gallery

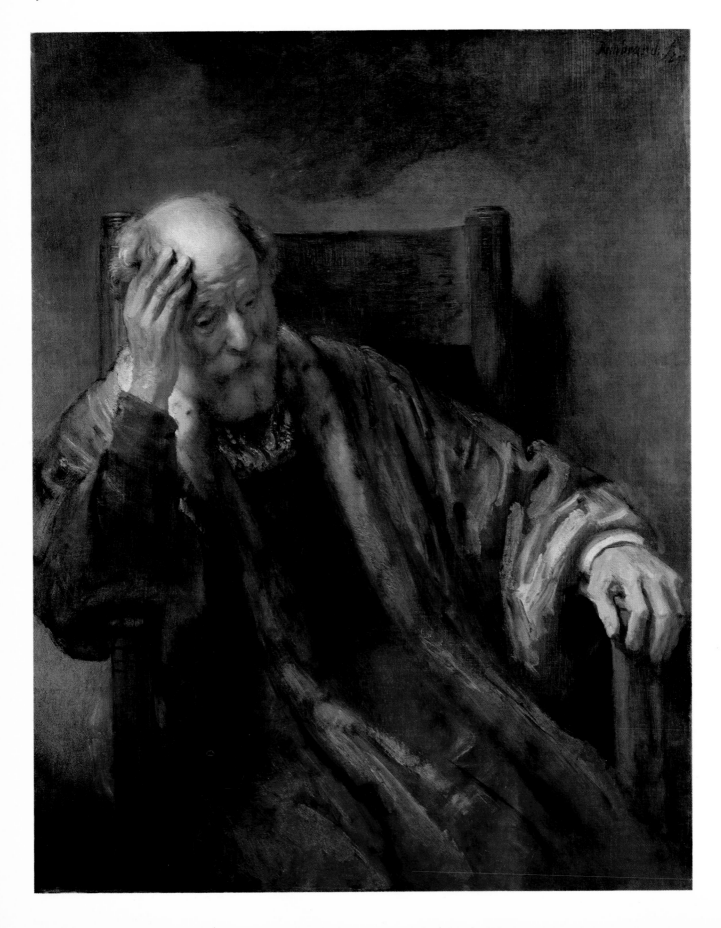

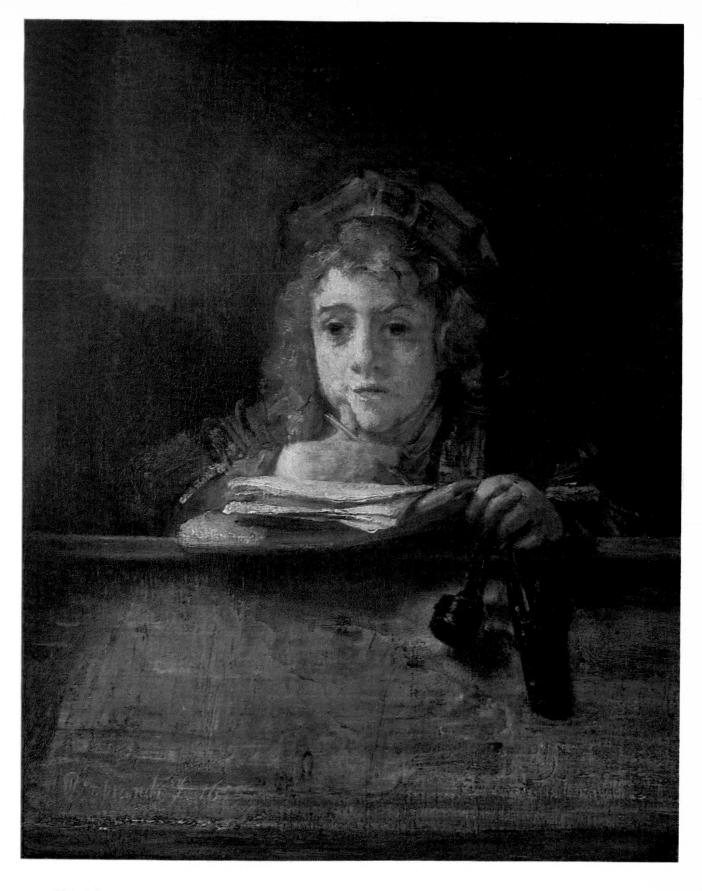

31. PORTRAIT OF TITUS. 1655. Rotterdam, Boymans-van Beuningen Museum

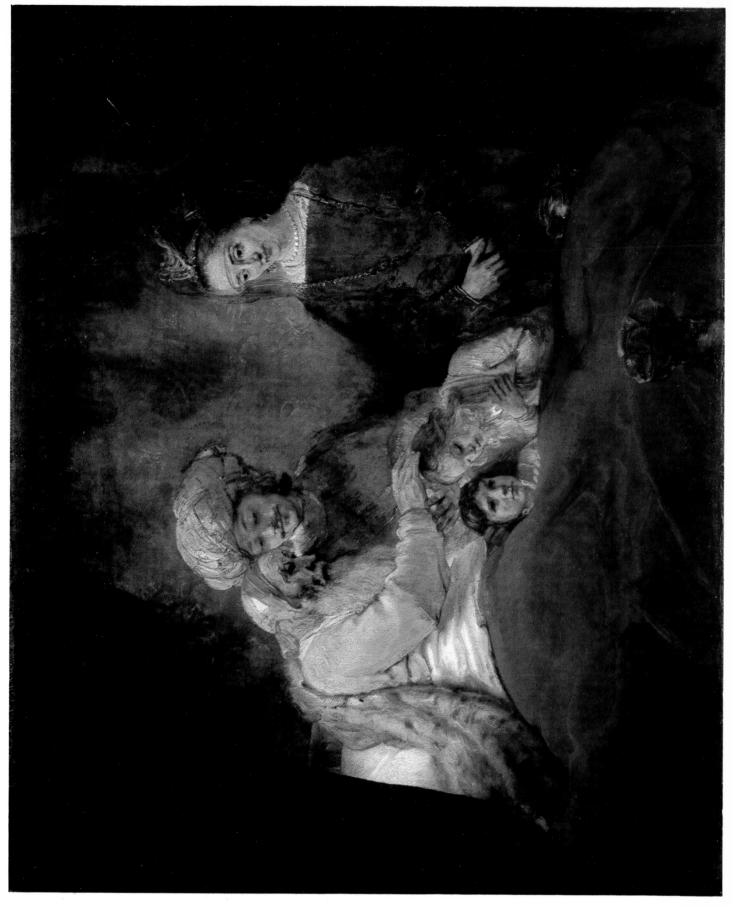

33. JACOB BLESSING THE CHILDREN OF JOSEPH. 1656. Cassel, Gemäldegalerie

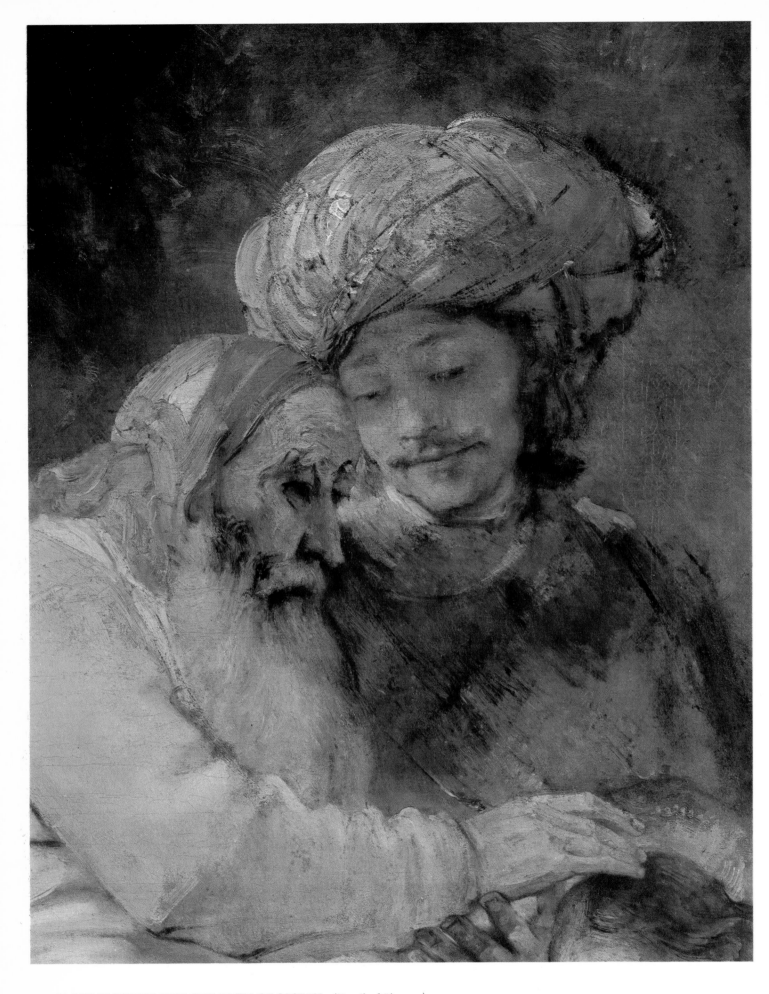

34. JACOB BLESSING THE CHILDREN OF JOSEPH (Detail of Plate 33)

35. JACOB BLESSING THE CHILDREN OF JOSEPH (Detail of Plate 33)

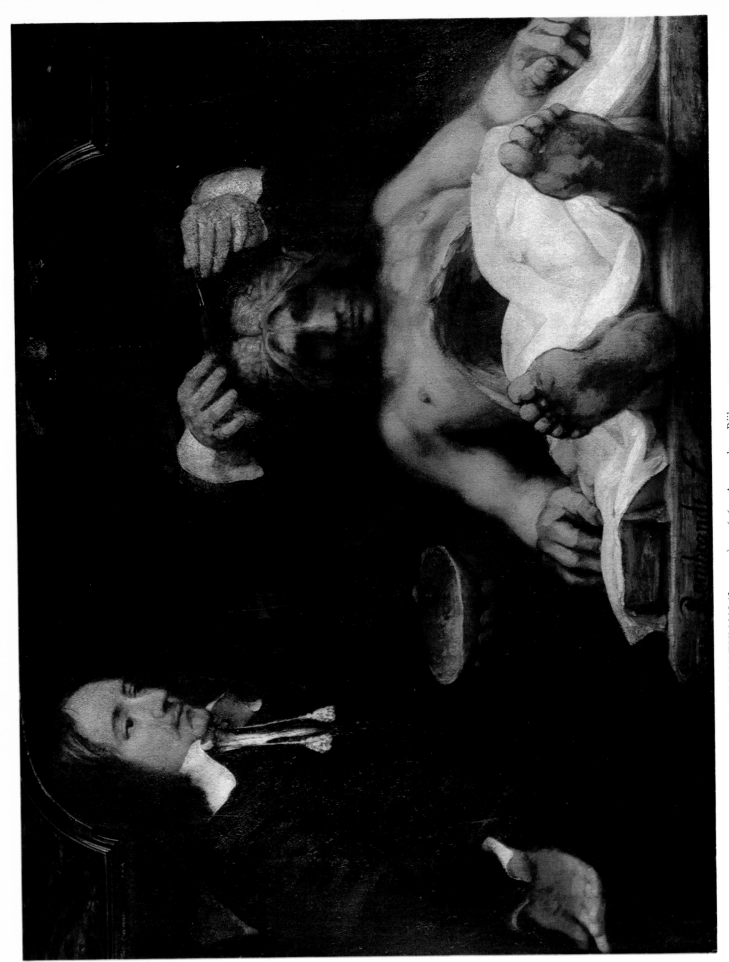

38. THE ANATOMY LESSON OF DOCTOR JOAN DEYMAN (fragment). 1656. Amsterdam, Rijksmuseum

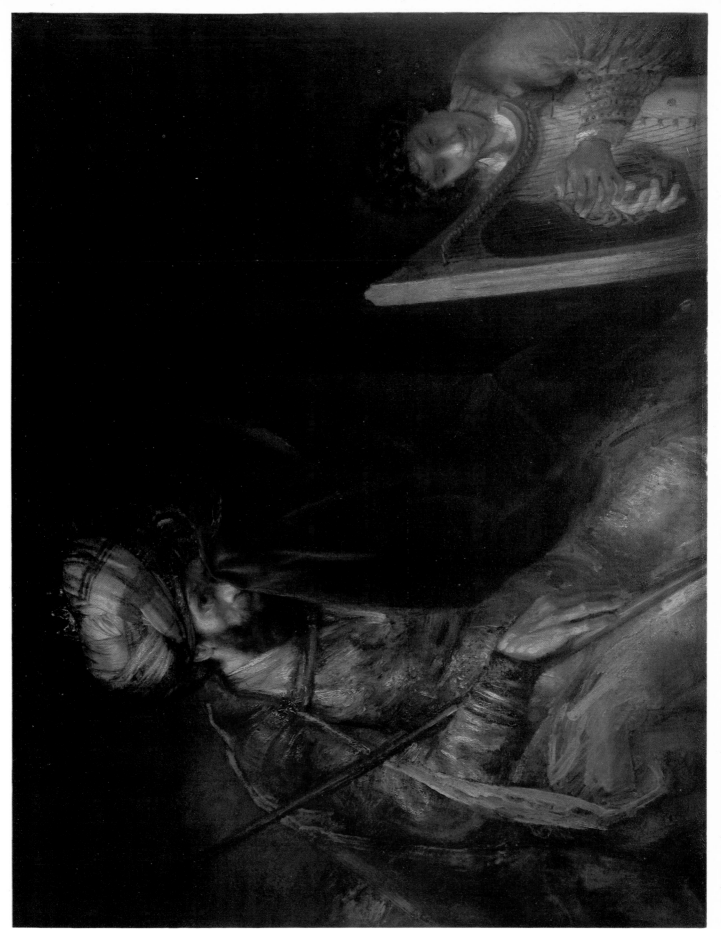

39.   DAVID PLAYING THE HARP BEFORE SAUL.    The Hague, Mauritshuis

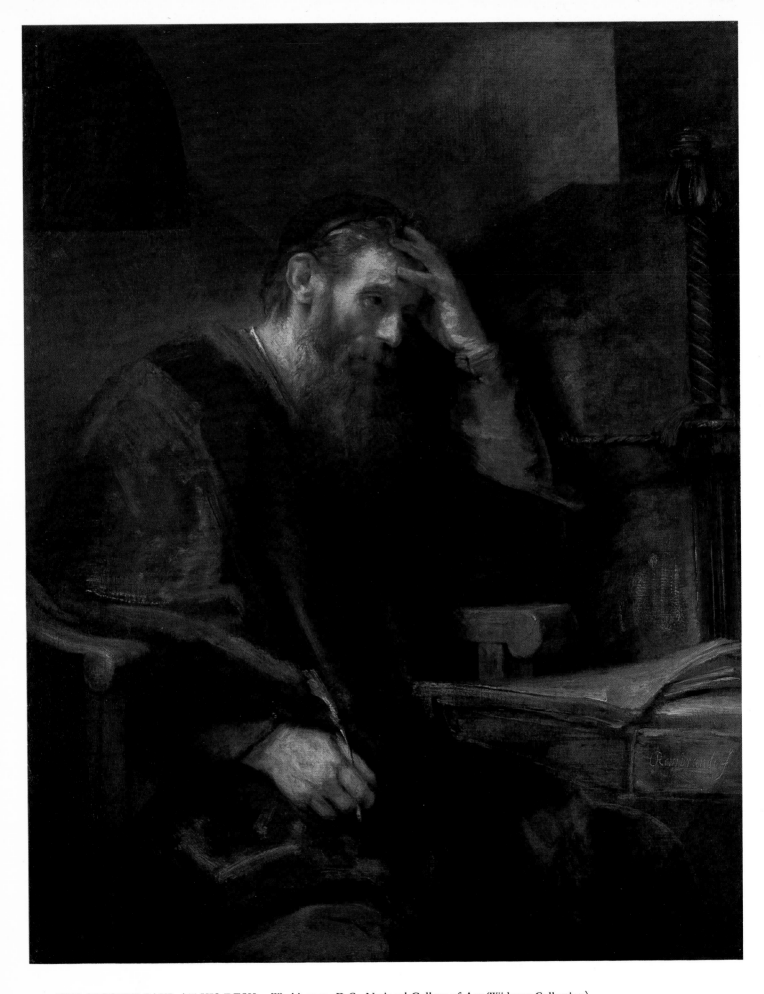

40.  THE APOSTLE PAUL AT HIS DESK.   Washington, D.C., National Gallery of Art (Widener Collection)

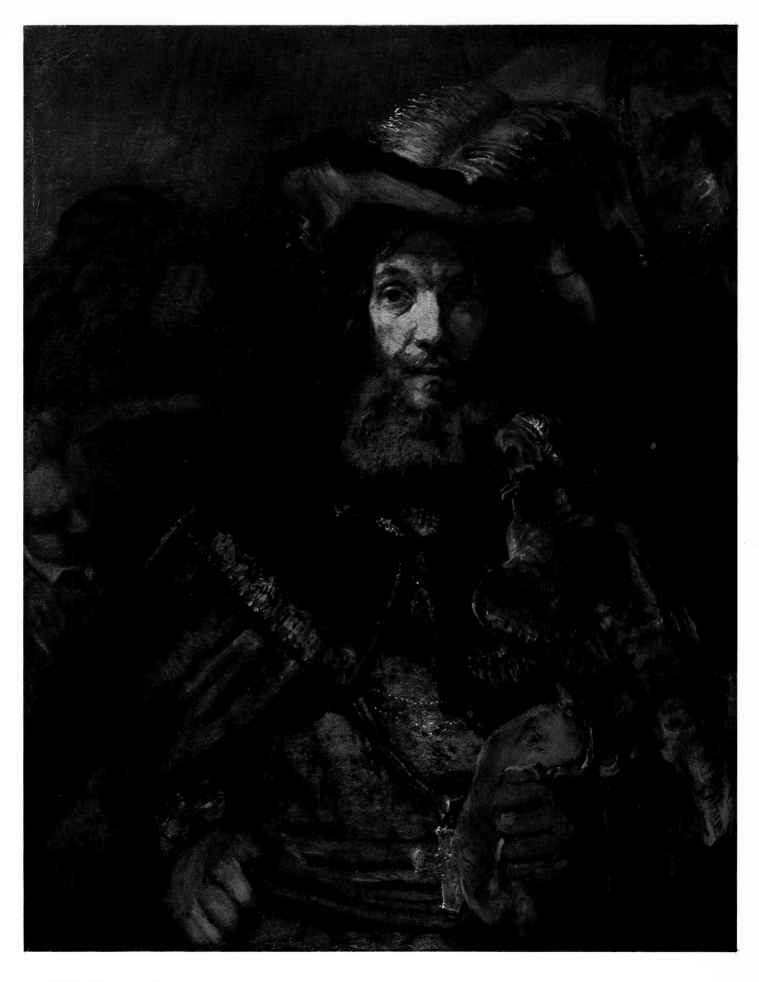

41. "THE FALCONER". Gothenburg, Museum

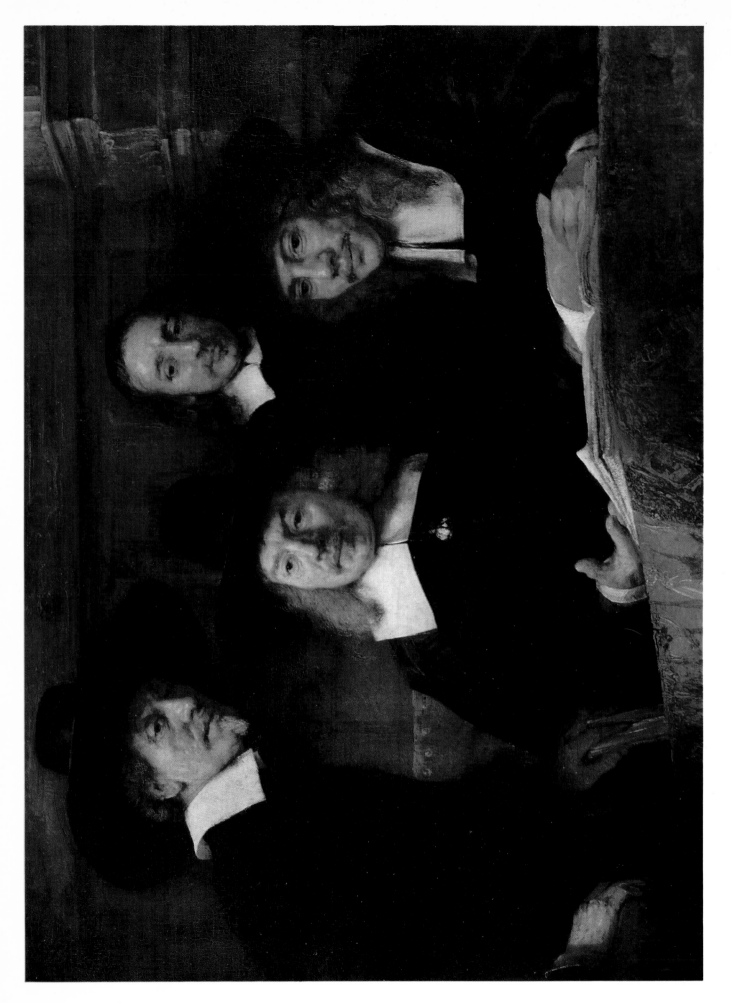

42. THE SAMPLING-OFFICIALS OF THE CLOTH-MAKERS' GUILD AT AMSTERDAM (THE SYNDICS). (Detail of Fig. 13). 1662. Amsterdam, Rijksmuseum

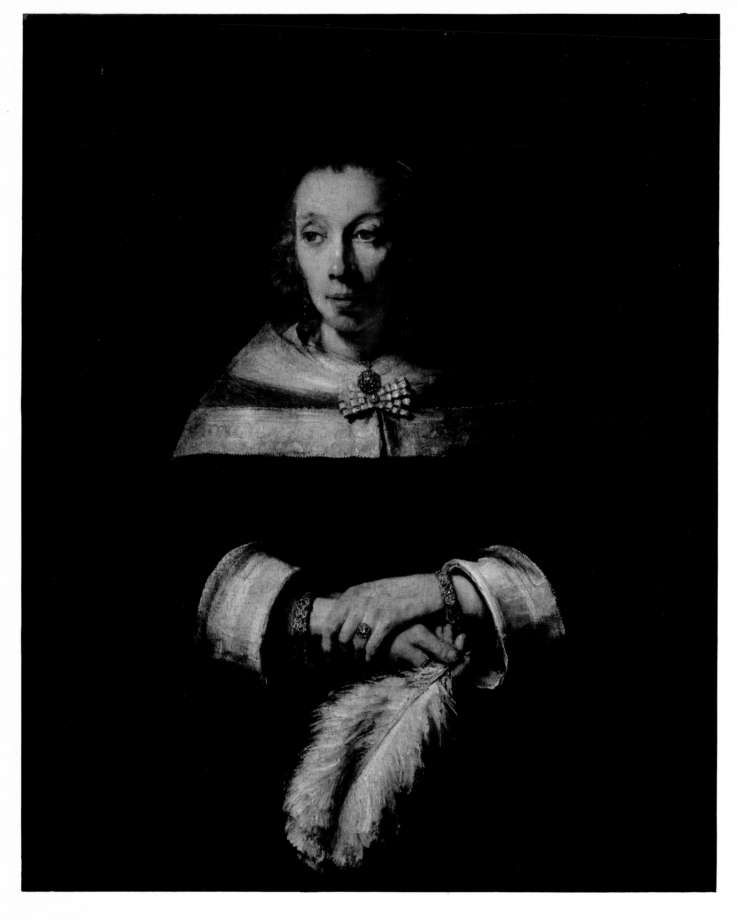

44. PORTRAIT OF A WOMAN HOLDING AN OSTRICH-FEATHER FAN. Washington, D.C., National Gallery of Art (Widener Collection)

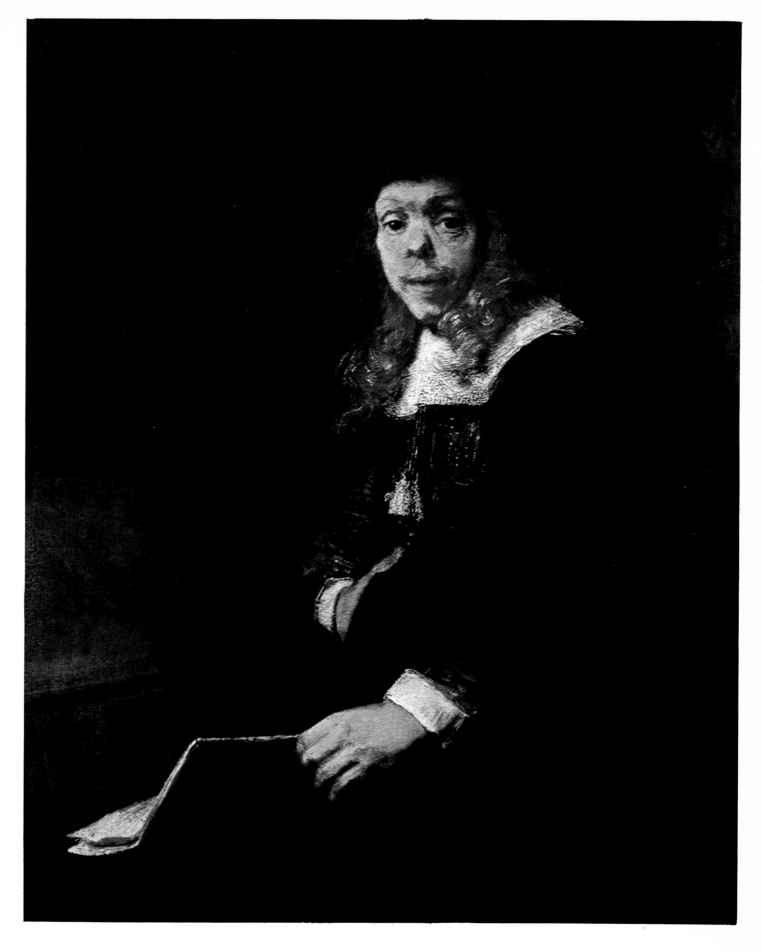

45. PORTRAIT OF THE PAINTER GERARD DE LAIRESSE. 1665. New York, Lehman Collection

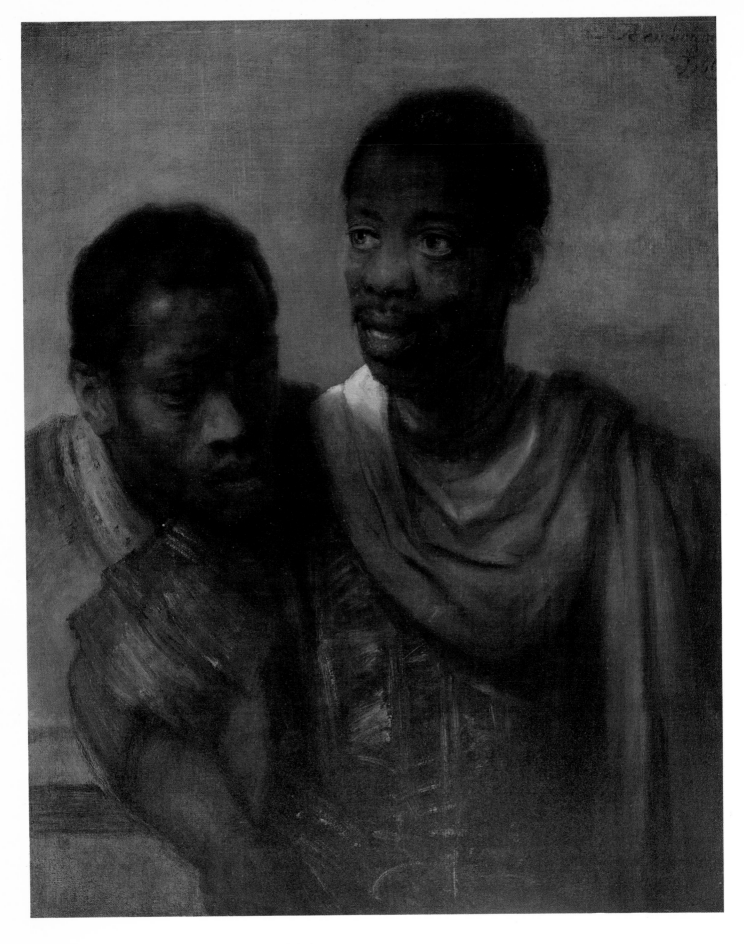

46. TWO NEGROES. 1661. The Hague, Mauritshuis

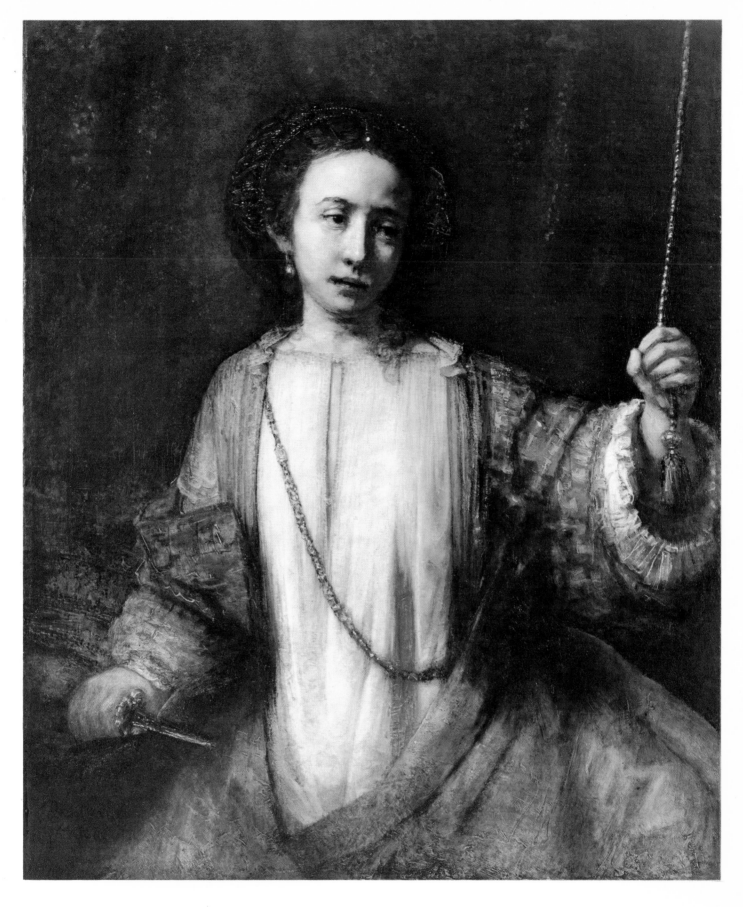

47. THE SUICIDE OF LUCRETIA. 1666. Minneapolis, Institute of Arts

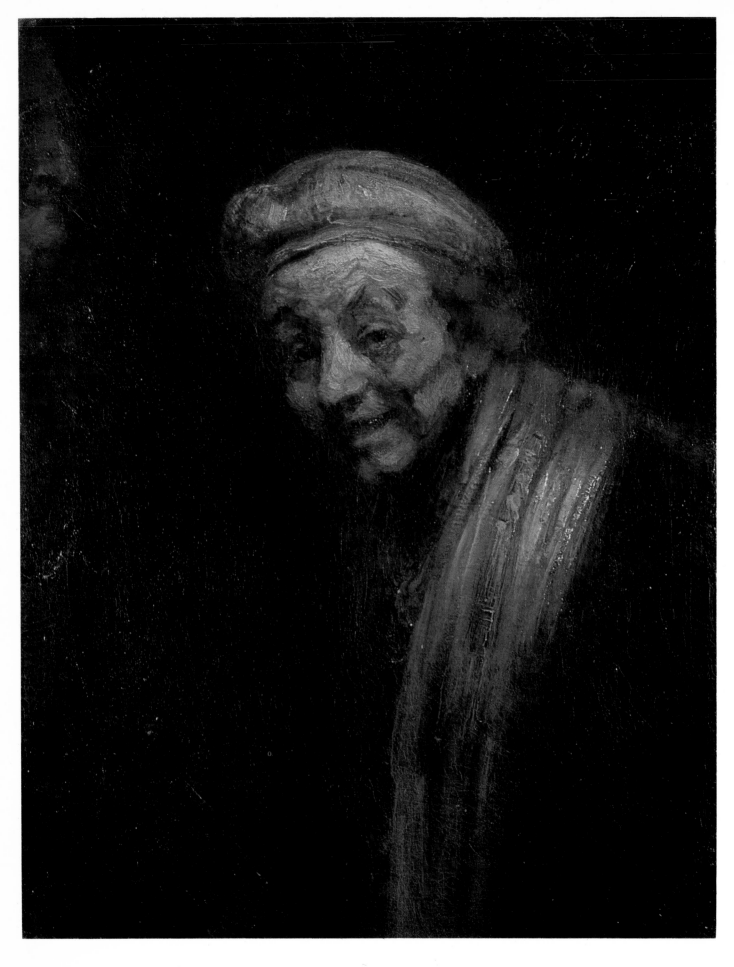

48.  SELF-PORTRAIT.  Cologne, Wallraf-Richartz Museum (von Carstanjen Bequest)

# Notes on the plates

**Frontispiece. Self-Portrait with Palette and Brushes** (detail). Canvas, 111×85 cm. Signed: *Rembrandt*. Br. 52; Bauch 331. London, Iveagh Bequest, Kenwood.

Painted about 1660; this is one of the noblest and most moving of Rembrandt's self-portraits. As in other cases where he represents himself as an artist, he corrects the lateral inversion of the image in the mirror, so that the palette appears as if held (as it would be) in the left hand. The segments of circles on the back wall, which also appear in the etching of the writing-master, *Willemsz van Coppenol* (Münz 80), of about the same date, remain unexplained.

**In text. Portrait of Jan Six** (detail). 1654. Amsterdam, Six Foundation. See note to pl. 36.

1. **Self-Portrait.** Panel, 41·2×33·8 cm. Signed with monogram. Br. 5; Bauch 298. Amsterdam, Rijksmuseum (2024/A 14).

This is one of a number of early self-portraits, comprising etchings and drawings as well as paintings, which Rembrandt made as practice studies of expression; painted about 1629/30. The etchings are perhaps the most important of this group. One etching of Rembrandt smiling, dated 1630 (Münz 12), is similar to this painting.

2. **Anna Accused by Tobit of Stealing the Kid.** Panel, 39·5×30 cm. Signed with monogram and dated: *1626*. Br. 486; Bauch 2. Amsterdam, Rijksmuseum (2024/A 12; on loan from Baroness Bentinck-Thyssen Bornemisza).

The subject is from *Tobit* (Apocrypha) II, 11–14. The blind Tobit, hearing the bleating of a kid which his wife, Anna, had been given as a present to supplement her earnings as a sewing- or washer-woman, self-righteously accuses her of having stolen it. This is the first of many representations by Rembrandt, in paintings, drawings and etchings, of stories from the book of *Tobit*. He was particularly fond of episodes involving the parents, Tobit and Anna, rather than the more usual theme of Tobias (their son) and the Angel, which was popular with landscape painters. The composition of this painting was adapted from an etching by Jan van de Velde after a drawing by Buytewech (see E. Havercamp Begemann, *Willem Buytewech*, Amsterdam, 1959, fig. 126).

3. **Two Scholars Disputing.** Panel, 71·5×58·5 cm. Signed with monogram and dated: *1628*. Br. 423; Bauch 5. Melbourne, National Gallery of Victoria (349/4).

The painting is discussed in detail by Ursula Hoff, *National Gallery of Victoria: Catalogue of Paintings before 1800*, Melbourne, 1961. It – or less probably the related picture in Dortmund (Bauch 6) – is listed in the inventory, dated 1641, of Jacob de Gheyn III as 'Two old men disputing . . . there comes the sunlight in'. De Gheyn (1596–1644) was a canon of St Mary's, Utrecht, and a draughtsman and engraver of *genre* figures; in this capacity he had a considerable influence on Rembrandt's early drawings, and Rembrandt painted his portrait (Bauch 353) in 1632. That the painting was regarded as a *genre* scene is characteristic of the period (cf. pl. 4), and this is basically what it is. However, as so often with Rembrandt, the picture has overtones of something more than a mere *genre* scene. Here, as in other pictures containing only one or two figures from the Leyden and early Amsterdam periods, Rembrandt lifts the representation out of an everyday context and sets it on a timeless plane. In some of these pictures he includes a symbol to indicate (say) St Paul or Bathsheba, but more often he evokes a generalized 'archaic' atmosphere, leaving the exact subject undeclared. This is not contradicted by the fact that at least one contemporary – the French print

publisher, Ciatres – went to the opposite extreme. Instead of calling Rembrandt's early works *genre* scenes, he published engraved copies of some of his 'heads' with fancy titles taken from antiquity and mediaeval legend, as early as the 1630's (see S. Slive, *Rembrandt and his Critics*, The Hague, 1953). There is a drawing from the life for the figure on the left (Ben. 7).

4. **Rembrandt's Mother** (?). Panel, 50×35 cm. Br. 70; Bauch 251. Royal Collection, Windsor Castle (reproduced by gracious permission of Her Majesty the Queen).

Given to Charles I by Sir Robert Ker, Earl of Ancram, before 1633; sold by the Commonwealth but recovered for the Royal Collection at the Restoration, 1660.

This is one of Rembrandt's first paintings to have been bought by a foreign collector and one of the first to arrive in England. Together with two other pictures by the artist, it was acquired by Sir Robert Ker, probably in 1629 when he was on a diplomatic mission to The Hague. If so, it must have been a very recent work, as it cannot be earlier than 1629 for stylistic reasons. It is not impossible that either Prince Frederick-Henry of Orange or his Secretary, Constantyn Huygens, or both, were Ker's immediate source. According to an inscription on the back, the picture was 'given by Sir Robert Ker' to Charles I, i.e. before 1633 when the former became Earl of Ancram. It is listed in the MS catalogue of Charles I's collections by Abraham van der Doort (c. 1638) as hanging in the long gallery at Whitehall Palace: 'Done by Rembrandt & given to the kinge by my Lo: Ankrom: Item . . . an old woeman with a great Scarfe upon her heade with a peaked falling band/In a Black frame' (see O. Millar, 'Abraham van der Doort's Catalogue of the Collections of Charles I', *The Walpole Society*, XXXVII, 1960, p. 60; also C. White, 'Did Rembrandt ever visit England?', *Apollo*, LXXVI, 1962, pp. 177–80).

It is interesting that contemporaries evidently regarded the picture as a *genre* piece (see previous note). The sitter was almost certainly the artist's mother (married 1589, died 1640), who appears in several other pictures of this period, and this one is to all intents and purposes a portrait of her. At the same time it has overtones of a religious painting and has sometimes been called 'Rembrandt's Mother as a Prophetess'; but it is unlikely that Rembrandt would have thought of it in that light. The great black headscarf was presumably a studio property as it reappears in Rembrandt's work as late as the 1650's (cf. pl. 37).

5. **An Officer.** Panel, 65×51 cm. Traces of an original monogram beneath a false signature, 'Rembrandt f.' Br. 79; Bauch 130. London, Sir Brian Mountain, Bt.

This picture, painted about 1629/30, is sometimes said to represent Rembrandt's father. In fact the only authenticated likeness of Harmen Gerritsz van Rijn – a drawing in the Ashmolean Museum, which bears a contemporary inscription to that effect (Ben. 56; repr., C. White, *Rembrandt and his World*, London, 1964, p. 8) – shows him as a much older man than this officer and with a long beard. He died in 1630 aged 70. The painting exemplifies the meticulous technique of Rembrandt's finished pictures of the period. In conception and in the dependence on the sharp silhouette it is slightly reminiscent of the fanciful paintings of figures in extravagant headgear by artists of the Utrecht School.

6. **An Artist in his Studio.** Panel, 25×31·5 cm. Br. 419; Bauch 112. Boston, Museum of Fine Arts.

The picture was first published by Hofstede de Groot in the *Burlington Magazine*, XLVII, 1925, p. 265, reporting that

additions to the panel of about 9 cm at the top and 3 cm at the bottom had been cut off by the then owner, the art historian Langton Douglas. Collins Baker (*Burlington Magazine*, XLVIII, 1926, p. 42) attributed the picture to Gerard Dou, which has not been accepted; J. G. van Gelder (*Mededelingen der Koninklijke Nederlandse Akademie van Wetenschappen*, N.S., XVI, 1953, p. 291), more plausibly, identified the painting as a study *of* Dou, on the grounds that the figure was too small for Rembrandt at this date (Dou became Rembrandt's first pupil in 1628 at the age of fourteen). However, it was persuasively argued by S. Slive in 1964 (*Burlington Magazine*, CVI, pp. 483–6) that the additions to the panel were by Rembrandt himself, although (in contrast to Rubens) he did not usually add to his panels in this way; an old photograph before the removal of the strips is reproduced in Slive's article and in Bauch, 112. The larger, upright format certainly corresponds better with Rembrandt's style at this period (1628/9), when he was beginning to open up the space of his compositions; a drawing of an artist at an easel (Ben. 390), though not directly related to the painting, supports this view.

### 7. The Presentation of Jesus in the Temple. Panel, 60 × 48 cm. Signed with monogram and dated: *1631*. Br. 543; Bauch 52. The Hague, Mauritshuis (145).
The subject is from *Luke* II, 22–32. A painting by Rembrandt on the same theme in Hamburg executed about three years earlier shows how his style had changed in the meanwhile. The treatment is no longer reminiscent of a *genre* scene, the composition is more complex and the space in relation to the figures is much enlarged. For further discussion of the picture, see p. 16. A semi-circular top added to the panel in the eighteenth century has now been concealed under the frame.

### 8. The Feast of Belshazzar: The Writing on the Wall (detail). Signed and dated: *Rembrand. f 163.* (last digit missing). London, National Gallery (6350).
See notes to pl. 12.

### 9. Doctor Nicolaes Tulp Demonstrating the Anatomy of the Arm (detail). Signed and dated: *Rembrandt, f 1632.* The Hague, Mauritishuis (146).
See notes to fig. 12.

### 10. A Young Woman in Fancy Dress. Panel, 98 × 70 cm. Signed and dated: *Rembrandt f. 1635* (?) Br. 104; Bauch 490. Château de Pregny (Geneva), Baron Edmond de Rothschild.
This is painted over an earlier, unfinished picture and has recently been restored. The restorer has read the date as 1638 but H. Gerson has pointed out (*Rembrandt* by A. Bredius, revised by H. Gerson, 1969) that as a painting by Rembrandt's pupil, Govaert Flinck, dated 1636, is based on precisely this kind of Rembrandt, the date cited by Bauch – 1635 – may therefore be correct. The figure has sometimes been identified as Rembrandt's wife, Saskia, but this is surely wrong, since the face is longer and more conventionally attractive than hers. On the other hand, there is some resemblance, both in the lighting and the costume, to the figure on the extreme left of *Belshazzar's Feast* (see pl. 8), which may have a bearing on the date of the latter picture.

### 11. Saskia as Flora. Canvas, 125 × 101 cm. Signed and dated: *Rembrandt f. 1634.* Br. 102; Bauch 258. Leningrad, Hermitage.
Rembrandt painted Saskia as Flora, the classical goddess of Spring, on at least one and possibly three other occasions. The best known is the picture in the National Gallery, London, dated 1635. The identification with Flora has been questioned. Sir Kenneth Clark suggested Proserpina (*National Art-*

*Collections Fund Annual Report*, 1939, p. 21), and N. Maclaren (*National Gallery Catalogue*, p. 334) has proposed that 'here Rembrandt was merely essaying the current Arcadian fashion'. That Rembrandt was influenced by contemporary Dutch pastoral painting as practised in Utrecht is beyond doubt, but the theme of both the Hermitage and National Gallery pictures is surely above all 'flowers'. Moreover the proffering of flowers with the hand in the National Gallery painting and the holding out of a single flower in pathetic irony by the sick Saskia in the portrait of her a year before her death (Dresden: Bauch 264) recall the gesture of the well-known classical statue of Flora in the Farnese Collection. Rembrandt used the same gesture in a much later painting (c. 1657; Bauch 282) in the Metropolitan Museum, perhaps using Hendrickje Stoffels as the model. For further discussion of the Hermitage picture, see p. 26.

### 12. The Feast of Belshazzar: The Writing on the Wall. Canvas, 167 × 209 cm. Signed and dated: *Rembrandt f. 163.* (last digit missing). Br. 497; Bauch 21. London, National Gallery (6350).
The subject is from *Daniel* V. Belshazzar, feasting with his family and concubines from the vessels taken by his father, Nebuchadnezzar, from the temple at Jerusalem, is rudely interrupted by the appearance of the finger writing on the wall foretelling his doom: MENE, MENE, TEKEL, UPHARSIN. Rembrandt, contrary to western pictorial tradition, depicts the words clearly in Hebrew script. They read vertically downwards, beginning at the top right, as it were to explain why Daniel had to be brought in to decipher them. As R. Haussherr has shown (*Oud Holland*, LXXVIII, 1963, pp. 142–9), the form of the wording follows Jewish, not Christian, literature, and is very close to the version in Menasseh ben Israel's *De termino vitae*, published in Amsterdam in 1639. Some critics, notably Haussherr and Bauch, have concluded that the picture must have been painted in that year. Others have seen this as definitely too late a date on stylistic grounds. It has been said (e.g. in the National Gallery *Report*, 1962–64) that Rembrandt could have had previous access to Menasseh ben Israel's text or to his research (the resemblance in the lettering is too close for coincidence); this may well be so, as he portrayed Menasseh ben Israel in an etching in 1636 (Münz 56). K. Roberts has pointed out (*Connoisseur Year Book*, 1965, pp. 65–70) that the general conception of the painting is still dependent on Lastman. Sir Kenneth Clark (*Rembrandt and the Italian Renaissance*, 1966, p. 107) has identified a probable source in Veronese's *Rape of Europa* in the Ducal Palace, Venice, for the pose of the woman on the right. 'About 1635,' or even a year or two earlier, is perhaps the most likely date for stylistic reasons.

### 13. Landscape with a Church. Panel, 42 × 60 cm. Br. 446; Bauch 549. Madrid, Duke of Berwick and Alba.
A Northern Gothic church and a Dutch drawbridge are the central features of this composition but they are situated in a small ancient town of vaguely Turkish character and a remote, ghostly landscape. Essentially, Rembrandt conjures up a sort of Near Eastern antiquity of no specific time or place, made all the more romantic and mysterious by the western travellers who approach the city. The picture was probably painted in the early 1640's and reflects the influence of Hercules Seghers, eight of whose landscapes were in Rembrandt's collection. The composition shows the general trend towards simplification and tranquillity in Rembrandt's style at this time. The same tendency is also apparent in the evolution of Dutch realistic landscape painting in the 1640's (cf. the work of Van Goyen and Salomon van Ruysdael).

14. **Self-Portrait.** Panel, 63·5 × 50·8 cm. Signed and dated: *Rembrandt f. 163.* (last digit missing). Br. 32; Bauch 313. Liverpool, Walker Art Gallery (on loan from Lt.-Col. A. Heywood-Lonsdale).

Painted about 1639; the expensive yet un-flashy costume and stable, classic pose, with the body at an angle and the head turned towards the observer, are typical of the period. About half-a-dozen other self-portraits belong to the same category.

15. **Uzziah Stricken with Leprosy (?)** Panel, 105 × 80 cm. Signed and dated: *Rembrandt f 1635.* Br. 179; Bauch 164. Chatsworth, Derbyshire, the Trustees of the Chatsworth Settlement.

'Uzziah stricken with leprosy' (2 *Chronicles* XXVI) is the latest interpretation of the subject of this painting. King Uzziah was banished from the temple and stricken with leprosy for presuming to burn incense at the altar, a privilege reserved for the priests. If Rembrandt had really intended to represent this figure he would surely have shown him holding a censer, as the text relates. Moses, Aaron and the 16th-century physician and wizard, Paracelsus, are other suggestions that have been put forward, none of them quite convincing. The difficulty – not uncharacteristic – is that Rembrandt includes no definite iconographical symbol on which identification might depend; yet, unlike most of his figures in this category, the expression is not one of contemplation or repose. On the contrary, the face is tense with fear or rage; this would fit Uzziah, or some other Old Testament figure.

16. **Portrait of Agatha Bas.** Canvas, 104·5 × 85 cm. Signed and dated: *Rembrandt f. 1641.* Br. 360; Bauch 501. Royal Collection, Buckingham Palace (reproduced by gracious permission of Her Majesty the Queen).

The companion portrait of the sitter's husband, also dated 1641, is in the Brussels Gallery (Bauch 386); they remained together until 1809. The identification of the sitters as the wealthy Amsterdam merchant, Nicolaes van Bambeeck, and his wife, Agatha Bas (1611–58), is due to I. H. van Eeghen (*Een Amsterdamse Burgemeestersdochter van Rembrandt in Buckingham Palace*, 1958). They were typical of the class of high merchant and diplomatic society which sat to Rembrandt in fairly large numbers in the 1630's and early 1640's. However, by this stage the interpretation is becoming both more personal and more intense than it had been in the previous decade. In fact this portrait belongs to a phase (which includes 'The Night Watch'), during which Rembrandt seems to have been more than usually interested in illusionism. The figure stands in a painted opening which has often been interpreted as a window but which may rather be intended to represent a picture frame. The fan and the left thumb overlap this frame, helping to create the impression that the sitter is actually present. The intentness of the gaze and the brilliant painting of the fan and the embroidered bodice further accentuate the illusion. These devices recall the Baroque, although the portrait is quite un-baroque in composition and pose.

17. **The Militia Company of Captain Frans Banning Cocq ('The Night Watch')** (detail). Signed and dated: *Rembrandt f. 1642.* Amsterdam, Rijksmuseum (2016).
See notes to fig. 10.

18. **The Entombment of Christ.** Panel, 32 × 40 cm. Br. 554; Bauch 74. Glasgow University, Hunterian Collection.
Possibly No. 111 in Rembrandt's inventory, 1656 – 'One sketch of the Entombment of Christ by Rembrandt'.
This monochrome sketch in oils is fairly closely related to the painting of the same subject which Rembrandt completed for Prince Frederick-Henry of Orange in 1639 (cf. note to fig. 3), now in Munich. According to Rembrandt's own statement in a letter, the Munich painting was 'more than half done' in February 1636. It is possible that the Glasgow sketch is a study for the central group of figures in this painting. However, the stylistic evidence for the connection would be stronger if the statement was in fact an untruth and if the painting (and therefore the sketch) had been begun as well as finished in 1639. Both compositions already show the trend towards a calmer, more introspective style which first revealed itself in Rembrandt's work at the very end of the 1630's. Indeed, if anything, the sketch shows this more than the painting. Perhaps for this reason, Bauch has dated the sketch in the early 1640's and has suggested that it was a study for an unexecuted etching. No other oil sketches for the series of paintings for Prince Frederick-Henry are recorded or have survived.

19. **Christ and the Woman Taken in Adultery.** Panel, 83·8 × 65·4 cm. Signed and dated: *Rembrandt. f. 1644.* The top corners of the panel were apparently rounded after the picture was painted. Br. 566; Bauch 72. London, National Gallery (45).

This painting probably appears in the inventory, dated 1657, of the Amsterdam dealer, Johannes de Renialme, in which it was valued at 1,500 guilders (half as much again as any other painting in his collection); it was later owned by Willem Six (nephew of Jan Six), at whose sale in Amsterdam in 1734 it was bought in at 2,500 guilders; after apparently remaining with the Six family until 1803, it was bought in at a London sale in 1807 at 5,000 gns and sold the following day to J. J. Angerstein, from whom it was acquired by the National Gallery in 1824.

The subject is from *John* VIII. The high price at which the picture was valued from Rembrandt's lifetime down to the early 19th century bears witness to its popularity during that period. It was probably always a 'collector's piece' and is the kind of relatively early, highly finished Rembrandt which appealed to the taste of the 17th, 18th and early 19th centuries. Indeed it looks as if the artist deliberately – and exceptionally – painted the central figure group in an earlier, more finished style than was usual for the date (1644), no doubt to please the patron. The bright colours and meticulous brushwork used for this group are in the manner of *The Presentation in the Temple* of 1631 (pl. 7); the composition is also reminiscent of that painting. However, the secondary figures are handled more broadly and the receding diagonals of the earlier work have been rearranged so as to form a pattern more nearly parallel to the picture plane.

The fullest account of the painting is to be found in N. Maclaren, *National Gallery Catalogue*, pp. 308–11.

20. **Portrait of the Painter Hendrick Martensz Sorgh.** Panel, 74 × 67 cm. Signed and dated: *Rembrandt f. 1647.* Br. 251; Bauch 394. London, Trustees of the 2nd Duke of Westminster and Anne, Duchess of Westminster.

This portrait together with its companion (pl. 21) is a good example of Rembrandt's use of the traditional Dutch motive of the paired painting of husband and wife, particularly well known from the work of Frans Hals. There is a clear but not overstressed visual and psychological relationship between the two figures. The paintings exemplify Rembrandt's style in commissioned portraits of the mid- and late-1640's: relatively clear in the handling and disposition of light and shade but with a subtle play of atmosphere over the features and a very dark background.

Hendrick Martensz Sorgh (c. 1611–70) was a minor Dutch painter of peasant scenes, active in Rotterdam. According to Houbraken he was a pupil of Teniers.

**21. Portrait of Adriaentje Hollaer, Wife of Hendrick Martensz Sorgh.** Panel, 74×67 cm. Signed and dated: *Rembrandt f. 1647*. Br. 370; Bauch 509. London, Trustees of the 2nd Duke of Westminster and Anne, Duchess of Westminster.
See notes to pl. 20 and pp. 26, 27.

**22. The Risen Christ Appearing to the Magdalene ('Noli Me Tangere').** Panel, 61×49·5 cm. Signed and dated: *Rembrandt f. 1638*. Br. 559; Bauch 66. Royal Collection, Buckingham Palace (reproduced by gracious permission of Her Majesty the Queen).
The subject is from *John XX*, 11–17. Christ carries a spade and wears the broad straw hat, traditional in art, in allusion to the Magdalene's mistaking Him for the gardener. The landscape (detail, pl. 24A) is particularly fresh and beautiful. On the back of the panel is a transcript of a poem in Dutch by Rembrandt's friend, Jeremias de Dekker (1609/10–1666), first published in 1660 in *De Hollantsche Parnas*, an anthology of poetry which contained several references to Rembrandt:

As I read the story told to us by Saint John
And there beside it see the picture, then I think:
When has the pen ever been so faithfully copied by the brush
Or dead paint been so nearly brought to life?
Christ seems to say: Mary, be not afraid,
It is I, and death no longer has any part in thy Lord:
She, as yet only half believing this,
Seems to hover between joy and sorrow, hope and fear.
The rock of the grave rises by art high into the air
And, rich with shadows, gives a majesty
To the whole work. Your masterly strokes,
Friend Rembrandt, have I seen first pass over the panel,
Therefore shall my pen write a poem on your gifted brush
And my ink speak the fame of your paint.

In the heading to the poem, de Dekker states that he had seen Rembrandt painting the picture for the Amsterdam clerk and sick-visitor, H. F. Waterloos. It must be this picture that is referred to, not the one of the same subject executed in 1651, now in Brunswick (Bauch 83).

**23. The Holy Family with Angels.** Canvas, 117×91 cm. Signed and dated: *Rembrandt f. 1645*. Br. 570; Bauch 73. Leningrad, Hermitage.
This is the second (or third, assuming that the picture formerly in the Kincaid-Lennox collection and now in the Rijksmuseum is authentic) of Rembrandt's series of paintings dating from the 1640's of the Holy Family. There are also a number of drawings and etchings of the same period on this theme. In all of them except the Kincaid-Lennox picture, Joseph is working in the background at his carpentry but this is the only painting in which angels appear. It is also the most poetic of the series and the one in which Rembrandt concentrates most fully on the Mother and Child. There is a brilliant pen and ink sketch for the painting in Bayonne, showing how Rembrandt conceived the composition in almost geometrical terms, whereby 'not only solids but rays of light turn into tracks of energetic line' (quoted from Ben. 567). A small oil sketch of a head seen from an angle similar to the Madonna's was identified as Hendrickje Stoffels by Valentiner (*op. cit.*, p. 406), who read an uncertain date on it, 1653. Rosenberg (*Rembrandt*, 2nd ed., London, 1964, p. 196, repr.) disregarding the date, believes this head to be a study for the Madonna in the Hermitage painting. However, its authenticity was already doubted by Bredius (375) and Bauch has called it a palpable copy. To judge from a reproduction it does not look genuine. It is unlikely that Hendrickje was the model for the Madonna (cf. note to pl. 25).

**24A. The Risen Christ appearing to the Magdalene ('Noli Me Tangere')** (detail). Signed and dated: *Rembrandt f. 1638*. Royal Collection, Buckingham Palace (reproduced by gracious permission of Her Majesty the Queen).
See notes to pl. 22.

**24B. Winter Landscape.** Panel, 16×22 cm. Signed and dated: *Rembrandt f. 1646*. Br. 452; Bauch 552. Cassel, Gemäldegalerie.
This is one of Rembrandt's very few naturalistic landscape paintings. Its stillness, clear atmosphere and planar composition relate it to the contemporary winter landscapes of Jan van Goyen and Isaac van Ostade, but the vigorous brushwork is Rembrandt's own. It is also unusual among Dutch landscapes of the 1640's in suggesting the unpleasantness of winter – thus anticipating the winter landscapes of Jacob van Ruisdael.

**25. A Young Girl Leaning on a Window Sill.** Canvas, 77·5×62·5 cm. Signed and dated: *Rembrandt ft. 1645*. Br. 368; Bauch 268. London, Dulwich College Gallery.
This is the first of a series of paintings by Rembrandt dating from the mid-1640's to the early 1650's representing a young girl, although they are not necessarily all of the same model. She wears a very simple dress and is sometimes depicted as a servant. It is tempting to identify at least some of these paintings with Hendrickje Stoffels, who is sometimes said to have entered Rembrandt's household about 1645/6, although the first documented reference to her is not until 1649. The very young girl in the Dulwich picture can hardly represent her, as Hendrickje was already about twenty in 1645. A black chalk drawing (Ben. 700) in the Seilern Collection is almost certainly a study for the painting (see *Paintings and Drawings of Continental Schools... at 56 Princes Gate, London, S.W.7*, No. 192.)

**26. A Woman Bathing.** Panel, 61·8×47 cm. Signed and dated: *Rembrandt f 1655*. Br. 437; Bauch 278. London, National Gallery (54).
The painting is discussed in detail by N. Maclaren, *National Gallery Catalogue*, pp. 312–5. He makes out a good case for identifying the figure with Hendrickje Stoffels, on the grounds of the similarity of the face with four portraits which are clearly of the same woman, who for that reason has the best claim to be Hendrickje. The 1656 inventory of Rembrandt's collection includes at least two oil studies by him of the nude female model. It is not suggested that the *Woman Bathing* is one of them, as she is partly clothed and the background is relatively complete; however, the association with such studies is perhaps relevant. While it is true that the pictorial idea may be reminiscent of a *Susanna* or *Bathsheba* at the bath (note the rich drapery in the background), the treatment shows neither the psychological drama nor the poses appropriate to those themes. It is essentially a personal work, sketchlike in handling and determined solely by Rembrandt's own interests as a man and an artist. It does not fit into any recognized 17th-century category, nor can it have been commissioned by a patron, although the fact that it is signed and dated suggests that it may have been sold.

**27. Head of Christ.** Panel, 25×20 cm. Br.622; Bauch 215. Berlin-Dahlem, Gemäldegalerie (811C).
This painting is one of a series of small studies of the head of Christ executed by Rembrandt probably in the early 1650's. All were done from the same model although the features are varied slightly. The face is given a Jewish appearance, clearly different from that of the Italian conception of Christ. It is dis-

tinguished by narrow cheeks, wide-set eyes and a thick black beard and hair, the latter parted low over the forehead. The lips are slightly open and the eyes have a sorrowful, yearning expression.

### 28. The Vision of Daniel. Canvas, 96×116 cm. Br. 519; Bauch 29. Berlin-Dahlem, Gemäldegalerie (828F).

The subject is from *Daniel* VIII; painted about 1650. In a vision, Daniel finds himself beside the river of Ulai and witnesses across the river the struggle of a ram and a he-goat, from which the latter emerges victorious. Both animals have fantastic horns which symbolize the power of warring kings. The angel Gabriel appears beside Daniel to explain the vision. Daniel at first collapses with fear but the angel touches him and guides him to his feet. Rembrandt's rendering of the story is extremely accurate, especially from the psychological point of view. Both Daniel's fear and the angel's role as comforter and interpreter of the vision are marvellously conveyed, and the mysterious rocky landscape is a superb evocation of the hallucinatory world of a dream. In his mature and late Biblical paintings, Rembrandt was more and more concerned with the psychological poignancy of a story, as distinct from its outward incidents (contrast *Belshazzar's Feast*, pl. 12). Another feature of his mature art that is well exemplified here is his conception of an angel, which is again totally different from Italian tradition; the angel is short with stubby wings, a long gown like a surplice and long blond hair falling over the face. There is a drawing for the painting in the Louvre (Ben. 901). The picture was much admired by Sir Joshua Reynolds, who once owned it, and was called by him 'Rembrandt's finest work'.

### 29. Susanna Surprised by the Elders. Panel, 76×91 cm. Signed and dated: *Rembrandt f. 1647*. Br. 516; Bauch 28. Berlin-Dahlem, Gemäldegalerie (828E).

This is perhaps the picture of Susanna bought from Rembrandt in 1667 for 500 guilders (*Oud Holland*, 1885, p. 92); like the *Vision of Daniel*, although the two pictures are not a pair, it was later owned by Sir Joshua Reynolds.
The subject is from *The History of Susanna* (Apocrypha). The two elders, hidden in the garden, threaten Susanna that they will publicly accuse her of committing adultery with a young man if she will not yield to them. In contrast to most representations of the theme, Rembrandt's painting is not a scene of violence. Susanna's awareness of her dilemma is written on her face as she attempts to cover her nakedness: 'Then Susanna sighed and said, I am straightened on every side: for if I do this thing it is death to me: and if I do it not I cannot escape your hands.'
The subject, like that of Bathsheba, had a continuing fascination for Rembrandt, reflecting his strong sensuality. He made two other paintings of it besides the present one, together with numerous drawings. He developed the Berlin painting, which is much the finest, out of a painting by Lastman, which he copied in a drawing (Ben. 448; all three works of art are in the Berlin museum), and his own earlier painting (dated 1637) in the Mauritshuis. Ben. 159, 536 and 592 are composition studies connected with the painting; Ben. 155-8, 590 and 591 are studies of individual figures or heads. All were done over a period from the mid-1630's to 1647, the date of the picture. Ben. 609, 928 and 977 are further composition studies, the first possibly, the other two certainly, later than the picture. Several major *pentimenti* are visible under the surface, which were once thought to indicate that the painting was begun much earlier. However, both the previous and final stages are now all considered to belong to the same period.

### 30. An Old Man Seated in an Armchair. Canvas, 111× 88 cm. Signed and dated: *Rembrandt f. 1652*. Br. 267; Bauch 206. London, National Gallery (6274).

N. Maclaren (*National Gallery Catalogue*, p. 337) suggests that the painting may be reminiscent of a Tintoretto portrait. For further discussion, see p. 28.

### 31. Portrait of Titus. Canvas, 77×63 cm. Signed and dated: *Rembrandt f. 1655*. Br. 120; Bauch 411. Rotterdam, Museum Boymans-Van Beuningen (St. 2).

This is the earliest dated portrait of Rembrandt's son Titus (1641–68). He was the only child of Rembrandt and Saskia to live beyond infancy. He was an artist, and several drawings by him are known. Rembrandt did not paint him either as a very young child or, apparently, as a young man in his twenties; but from c. 1653 to c. 1661 there are at least eight portraits of him, besides a number of drawings of him and paintings of religious figures for which he may have acted as a model. After Saskia and Rembrandt himself, Titus is the most consistently recognizable figure in the artist's *oeuvre*. The front of the desk, with its varied textures, is an astounding piece of painting.

### 32. 'The Polish Rider'. Canvas, 115×135 cm. Signed: *Re . . .* (the rest of the signature missing). The painting has been cut down by about 12 cm along the bottom and at the right; strips painted to match the original have been added to restore the canvas approximately to its former size. Br. 279; Bauch 211. New York, Frick Collection.

The subject of this picture, perhaps the most poetic and curious of all Rembrandt's representations of the single figure, has given rise to much speculation. Almost the only thing not in doubt is its date, which is universally agreed to be about 1655. It is not obviously either a painting of a real or imaginary character from the past, or a portrait of a contemporary, or a *genre* study, although it has elements suggestive of all three. It was called a 'Cossack on Horseback' by its first recorded purchaser, Michael Casimir Oginski (see A. Ciechanowiecki, *Art Bulletin*, XLII, 1960), in a letter written probably from Amsterdam or The Hague in 1791 to his patron, Stanislas II Augustus of Poland; this may have been the title by which it was known in Holland at the time. Polish patriots in the early 19th century believed the figure to be an officer of the Lisowski regiment, a famous Polish mounted regiment which operated in western Europe during the Thirty Years War, although it was disbanded in 1636, twenty years before the picture was painted. The title, 'The Polish Rider', was given to the painting when it was bought from Poland by Henry Clay Frick in 1910.
Modern criticism of the picture began with a long article by J. Held in the *Art Bulletin*, XXVI, 1944. He maintained that the costume and weapons were not specifically Polish but broadly 'eastern European', perhaps with some Turkish elements, which Rembrandt evolved partly from imagination, partly from his collection of old clothes and partly from the use of engravings. Held suggested that Rembrandt conceived the painting as a generalized image of the Christian Soldier on the lines of Dürer's engraving of *The Knight, Death and the Devil* (although the meaning of the latter is itself uncertain). Valentiner, too, thought that the picture represented an imaginary figure (*Art Quarterly*, XI, 1948). He saw it as an ideal portrait of the legendary Dutch medieval hero, Gysbrecht van Aemstel, who visited Poland at one point in his career.
Recently, however, the traditional idea that the rider is a Polish cavalry officer of the 17th century has been revived. This is due to Z. Zygulski (*Bulletin du Musée National de*

*Varsovie*, VI, 1965), who has drawn on a wider range of comparative engravings than were available to Held and has cited surviving examples of 17th-century Polish costumes and weapons. Using both as a basis, he has argued strongly that Rembrandt painted the figure from life, wearing his own clothes. This suggestion is persuasive, if still not quite proved, and is borne out by the precision and consistency with which the details of the costume and weapons are painted; they do not look 'faked'. Moreover, if Zygulski's view is correct, the report that the picture was probably known as a 'Cossack on Horseback' in Holland in the late 18th century gains added significance; it may be a title which went back to Rembrandt's lifetime. Polish cavalrymen were fairly often to be seen in western Europe during the 17th century, and it would be characteristic of Rembrandt, with his love of the picturesque and the exotic, to have painted one.

Even so, the painting does not seem to be quite a portrait in the sense that, say, Rembrandt's only other single equestrian figure, the so-called *Frederik Rihel* of c. 1663 in the National Gallery, is a portrait. Although the pose of '*The Polish Rider*' with the hand on the hip and the head turned towards the observer belongs to a portrait-type, the treatment of the face is too indefinite for this to be the correct explanation. The fact that the figure is only half life-size also speaks against it. Above all, the landscape and the mood of the painting as a whole breathe, as all critics are agreed, an unforgettable air of mystery. The landscape has a spaciousness differentiating it from the conventional backdrop normal to a portrait. It contains a castle on a mountain in the background and a stream in the foreground, which the horse and rider are about to ford. The emaciated horse with its alert rider paces soundlessly through this landscape, its hooves barely touching the ground. Some narrative content seems to be hinted at. Yet no clue or symbol is visible which might allow us to identify a subject, nor is the costume—if this is indeed actual and contemporary – easily reconcilable with the notion either that the painting is a subject picture or that it is an imaginary portrait of a legendary or historical character. Might not the mysterious horseman be, after all, merely a figure study? – though to say 'merely' in this context is not to denigrate it. Is it not perhaps one of those 'subjects that are ordinary and without special significance, subjects that pleased him and were picturesque (*schilderachtig*), . . . and at the same time full of charm, sought out in nature,' as Sandrart said when describing Rembrandt's choice of subject matter? Few critics nowadays would be eager to believe this. And if it were true, it would be a unique case in 17th-century Dutch painting. But Rembrandt's art *is* unique. As we have seen elsewhere, he was capable of simultaneously painting figures from life without intending a subject and of endowing them with the beauty and force of a poetic idea, to a degree unknown in art before.

**33. Jacob Blessing the Children of Joseph.** Canvas, 177·5 × 210·5 cm. Signed and dated: *Rembran. . f. 1656*. Br. 525; Bauch 34. Cassel, Gemäldegalerie.
The subject is from *Genesis* XLVIII, 8–20. The essence of the story as told in the Bible is the unexpected action of Jacob in giving the chief blessing (with his right hand) to the younger son, Ephraim, and the lesser blessing (with his left hand) to the elder son, Menasseh. Joseph protests at this and tries to guide Jacob's right hand to Menasseh's head; however, Jacob refuses to change his mind and predicts that the younger son will be greater than the elder.
Most previous painters had illustrated the subject by showing Jacob with his hands crossed and Joseph reaching out to correct the supposed mistake. Rembrandt, however, under-stresses this side of the story and represents only the right hand

of Jacob blessing Ephraim. As W. Stechow has pointed out (*Gazette des Beaux-Arts*, XXIII, 1943), he seems to depend as much on Jewish legend as on *Genesis*, by giving prominence to Asenath, Joseph's wife, who is barely mentioned in the Bible and is not recorded as being present on this occasion. One Jewish version (quoted by Stechow) states that Asenath was brought in by Joseph to persuade Jacob to give his blessing, and that he does this, first blessing Ephraim, then Menasseh. There is no mention of any exchange of blessing by Jacob or of a protest from Joseph (nevertheless, in the Cassel painting Joseph's hand is gently placed under Jacob's wrist, as if to move it to the other boy's head). For another view see I. Manke, *Zeitschrift für Kunstgeschichte*, XXIII, 1960. There is an earlier drawing of the subject by Rembrandt, not directly connected with the picture (Ben. 509).

**34. Jacob Blessing the Children of Joseph** (detail). Signed and dated: *Rembran. . f. 1656*. Cassel, Gemäldegalerie. See notes to pl. 33.

**35. Jacob Blessing the Children of Joseph** (detail). Signed and dated: *Rembran. . f. 1656*. Cassel, Gemäldegalerie. See notes to pl. 33.

**36. Portrait of Jan Six.** Canvas, 112 × 102 cm. Br. 276; Bauch 405. Amsterdam, the Six Foundation.
In family possession since it was painted.
This is one of the most famous of all Rembrandt's male portraits. It was painted in 1654 (on the evidence of a couplet in a collection of poetry by the sitter). Jan Six (1618–1700) was well educated, travelled, a writer and a collector. He came of a wealthy merchant family but took up a career as a magistrate and was burgomaster of Amsterdam in 1691. Rembrandt probably first met him in 1641 when he painted Six's mother. Further links between the two men, which were continuous and probably close from 1647 to 1654, are recounted in C. White, *Rembrandt and his World*, London, 1964, and C. Bille, *Apollo*, LXXXV, 1967. After the portrait was painted it seems that the relationship cooled. In 1655 Six married a daughter of Dr Tulp.

**37. An Old Woman Reading.** Canvas, 79·3 × 66·6 cm. Signed and dated: *Rembrandt f. 1655*. Br. 385; Bauch 279. Drumlanrig Castle, Scotland, Duke of Buccleuch.
This is one of a series of paintings of an old woman dating from the early 1650's, all from the same model. In this one the face is illuminated by both direct and reflected light. The heavy black headdress is the same, with minor alterations, as that in the early portrait of *Rembrandt's Mother* (pl. 4).

**38. The Anatomy Lesson of Dr Joan Deyman** (fragment). Canvas, 100 × 134 cm. Signed and dated on the front edge of the table: *Rembrandt f. 1656*. Br. 414; Bauch 538. Amsterdam, Rijksmuseum (2018).
Coll: Formerly in the Dissecting Room of the Surgeon's Guild in the Sint Anthonieswaag in Amsterdam; after belonging to an English private collector in the 19th century, it was bought by the City of Amsterdam in 1882 and deposited in the Rijksmuseum in 1885.
The greater part of the picture was destoyed by fire on 8 November 1723; it has been calculated that the original dimensions were about 210 × 270 cm. A drawing by Rembrant in the Print Room of the Rijksmuseum (Ben. 1395) shows the layout of the composition. The corpse was centrally placed with the anatomist standing behind it, backed by what is apparently a large canopied throne. Four figures were grouped on each side, one of whom – the assistant holding the removed part of the cranium – can be seen in the part

of the picture which survives. The symmetry of the arrangement and the static poses offer a striking contrast to the *Anatomy Lesson of Dr Tulp* of twenty-two years earlier (fig. 12). The body is opened at the stomach, which presumably indicates that the picture represented a public, not a private, anatomy, although to judge from the drawing the space is somewhat confined. The criminal was Joris Fonteyn, who was sentenced to death for theft on 27 January 1656. The surgeon, Dr Joan Deyman (1620–66), succeeded Dr Nicolaes Tulp as chief anatomist and praelector of the Surgeons' Guild of Amsterdam in 1653. The painting was seen and admired in 1781 by Sir Joshua Reynolds, who said of it, *inter alia*: 'There is something sublime in the character of the head (of the corpse), which reminds one of Michelangelo; the whole is finely painted, the colouring much like Titian.' The drawing mentioned above shows not only the composition but also the frame; in fact it has been plausibly argued that it was made after the picture was finished, as a study for the frame. Pilasters are shown at either side, together with a base below and a carved, broken pediment above. It would have set the painting in a kind of tabernacle. A similar drawing for the frame of a painting of *St John the Baptist Preaching* is also known (Ben. 969). Neither frame actually survives, but it is interesting that a painted frame of a similar type forms part of the picture of *The Holy Family with the Cat* in Cassel (Bauch 77). For the possible significance of such carved, elaborate frames in relation to Rembrandt's art, see p. 29.

39. **David Playing the Harp Before Saul.** Canvas, 130·5 × 164 cm. Br. 526; Bauch 35. The Hague, Mauritshuis (621).

The subject is from I *Samuel* XVIII, 9–11; painted about 1657. The canvas was at one time cut down the middle, making two pictures, and a rectangular piece was removed from above the head of David. The two halves have now been re-joined and the missing area has been replaced by a restored piece of canvas. Bauch has suggested that a figure or figures may once have been dimly visible in this part, on the evidence of a mediocre drawing of the same subject (in reverse) in the Louvre (Ben. C 76), supposed to be a copy of a lost drawing by Rembrandt; this shows two figures peering between the curtains in the background.

In its present state the painting is strikingly Caravaggesque, but this may be exaggerated by the unrelieved darkness of the restored area at the top right. However, it is not only the dramatic, impenetrable *chiaroscuro* and the (for Rembrandt) unusually sharp tone contrasts that are reminiscent of Caravaggio, but also the placing of the two figures with a gap between them in the front plane and the pronounced assymetry of the composition. For another echo of Caravaggio in Rembrandt's late work, see notes to pl. 47.

40. **The Apostle Paul at His Desk.** Canvas, 129 × 102 cm. Signed: *Rembrandt f.* Br. 612; Bauch 221 (223 in catalogue). Washington, D.C., National Gallery of Art (Widener Collection).

This picture belongs to a series of single, half-length, life-size figures of apostles painted by Rembrandt in the late 1650's and early 1660's. The saint is identified as St Paul by his traditional attribute, the sword, visible in the background.

41. **'The Falconer'.** Canvas, 98 × 79 cm. Br. 319; Bauch 242. Gothenburg, Museum.

This picture was first published by Valentiner in *Rembrandt, KdK: Wiedergefundene Gemälde*, 1921, p. 97A. It was probably painted about 1661. In a later article ('Rembrandt's Conception of Historical Portraiture', *Art Quarterly*, XI, 1948),

Valentiner suggested that the figure was intended to represent the medieval Dutch hero, Count Floris V of Holland. He was lured to his death by his former associates, who included Gerard van Velsen and Gysbrecht van Aemstel, on the promise of a hunting expedition. Despite being warned of his danger by a woman of the people, he trusted his companions, rode out alone to join the hunt and was captured. This legend was extremely popular in Holland in the 17th century and was often re-told, both in histories of Amsterdam and in plays, notably Hooft's *Gerard van Velsen* (1612), which was frequently revived on the stage. The suggestion that Rembrandt's painting represents Count Floris is quite plausible; hunting with the falcon was his favourite recreation and he is shown with a falcon on his wrist in 17th-century engravings. In the painting he would be about to mount his horse, the melancholy expression in his eyes being caused by the warning he had received. Whether Rembrandt portrayed an actor in costume or invented the costume, using one of his ordinary models for the face, is difficult to say; on the whole the latter is more likely, as the same model seems to be used for other pictures during these years, when he appears as Christ, an apostle or an old man wearing everyday clothes.

42. **The Sampling-Officers of the Cloth-Makers' Guild at Amsterdam ('The Syndics')** (detail). Signed and dated: *Rembrandt f. 1662.* Amsterdam, Rijksmuseum.
See notes to fig. 11.

43. **The Conspiracy of Julius Civilis: The Oath** (detail). Stockholm, Nationalmuseum.
See notes to fig. 13.

44. **Portrait of a Woman Holding an Ostrich-Feather Fan.** Canvas, 98 × 82 cm. Signed and dated: *Rembrandt f. 166.* (last digit missing). Br. 402; Bauch 528. Washington, D.C., National Gallery of Art (Widener Collection).

This portrait, probably painted about 1665–8, is a companion piece to the *Portrait of a Man in a Tall Hat* (Bauch 446), also in Washington. The two paintings show how Rembrandt could rise to the occasion of a formal commissioned portrait even in the very last years of his life, without sacrificing his artistic integrity. The sitters, who are unknown, evidently belonged to the wealthy burgher class, which began to come back to him for portraits in the 1660's, after a relative falling off since the middle of the fifth decade. The two areas of light in the woman's portrait in Washington – the head and collar, and the hands, cuffs and fan – form two equilateral triangles, one inverted beneath the other with a space between them.

45. **Portrait of the Painter, Gérard de Lairesse.** Canvas, 112 × 87 cm. Signed and dated: *Rembrandt f. 1665.* Br. 321; Bauch 441. New York, Robert Lehman Collection.

The identity of the sitter was established by F. Schmidt-Degener (*Onze Kunst*, XXIII, 1913), by comparison with his engraved portrait in Houbraken's *De Groote Schouburgh*, 1718. Gérard de Lairesse (1641–1711) was a prolific painter, etcher and writer on art. Born in Liège, Flanders, he settled in Amsterdam in 1665, where he at first worked for the dealer, Gerard Uylenburgh, a relative of Saskia's cousin, Hendrik van Uylenburgh, with whom Rembrandt first lodged in Amsterdam. Lairesse went blind in 1689–90 as a result of venereal disease, the marks of which are already visible in Rembrandt's portrait of him. In his later years he devoted himself to art theory, publishing his most important book – *Het Groot Schilderboek* – in 1707. This is a compendium of the rules and principles of ideal art and is opposed to almost everything that Rembrandt stood for.

**46. Two Negroes.** Canvas, 77 × 63 cm. Signed and dated: *Rembrandt f. 1661* (?). Br. 310; Bauch 539. The Hague, Mauritshuis (685).

A painting of 'Two Moors, in one picture, by Rembrandt' is listed in Rembrandt's inventory of 1656 (344). It has been suggested that this may be an earlier stage of the Mauritshuis painting, which would then have been completed later. However, most critics are agreed that the picture was conceived and executed in a single period of time, and, although the reading of the date, 1661, is uncertain, it must be approximately correct for reasons of style. Apart from two oil sketches by Van Dyck, very few earlier life-size studies of negroes are known. In one bound, as it were, Rembrandt has succeeded in rendering the entire negro physiognomy with perfect sympathy and fidelity.

**47. The Suicide of Lucretia.** Canvas, 111 × 95 cm. Signed and dated: *Rembrandt f. 1666*. Br. 485; Bauch 286. Minneapolis, Institute of Arts.

The subject is from Livy, I, 57–8. Lucretia stabbed herself to death in shame after being ravished by Tarquin. Rembrandt painted another version of this subject two years earlier, now in Washington. In the Washington picture Lucretia seems to gaze almost lovingly at the dagger as she holds it pointed towards her heart. In the later painting in Minneapolis she has already driven it into herself once, and the expression on her face is one of stoical disgust. As Michael Hirst has observed (*Burlington Magazine*, CX, 1968), the pose, set of the head and expression are startlingly reminiscent of Caravaggio's *David with the Head of Goliath* in the Borghese Gallery, Rome. It is not impossible that Rembrandt came across an engraving or copy of this painting after completing the Washington *Lucretia*, which prompted him to conceive the more brutal and profound interpretation now in Minneapolis. Another possible echo of Caravaggio in Rembrant's late work has already been mentioned (see above, notes to pl. 39). There is a third, more certain one in the *Denial of St Peter* of 1660 in the Rijksmuseum, although in that case the direct source may be one of Caravaggio's Dutch followers such as Baburen or Honthorst. Taken separately these instances would not be significant but cumulatively they are interesting. They show that one of the two influences on the late Rembrandt was his greatest Italian predecessor in the search for a personal, anti-classical style. The other, which was manifest in a still deeper, more diffused sense, was Titian.

**48. Self-Portrait.** Canvas, 82 × 65 cm. Br. 61; Bauch 341. Cologne, Wallraf-Richartz Museum.

This was probably painted about 1667 and is one of Rembrant's last self-portraits. W. Stechow (*Art Quarterly*, VII, 1944), following up a suggestion by F. Schmidt-Degener, has argued that Rembrandt here represented himself in the guise of the Greek philosopher Democritus. There were literary precedents for this autobiographical self-projection, if such it was. Robert Burton, styling himself 'Democritus Junior' in the introduction to *The Anatomy of Melancholy* (1621), describes the philosopher as 'a little wearyish old man, very melancholy by nature, averse from company in his later days and much given to solitariness', yet one of excellent wit and a man who consoled himself by laughing heartily to himself at the follies of the world. The face half visible at the top left of the canvas appears to be a classical bust. Perhaps it was taken from a cast of a Roman emperor but Rembrandt may have intended it in this context to represent Democritus's counterpart, the 'weeping philosopher' Heraclitus.

## Notes on the Black and White illustrations

**1. Danaë.** Canvas, 185 × 203 cm. Signed and dated: *Rembrant f. .6.6.* Br. 474; Bauch 104. Leningrad, Hermitage.

This picture, painted in 1636, is Rembrandt's nearest approximation to a classical nude, following the tradition of Titian's many representations of a reclining Venus. It is perhaps his most assured artistic success on a large scale during the 1630's. The predominant colour is a cool, opulent gold with olive-green in the curtains and dull red in the tablecloth at the right. There has been much dispute about the subject, but the generally accepted view nowadays, proposed by Panofsky in 1933 (*Oud Holland*, L), is that the traditional title – *Danaë* – is correct. The picture may be identical with 'a large painting of Venus (*sic*) by Rembrandt' mentioned in the inventory of a certain Jan d'Ablijn in 1644 and is more certainly the 'large painting by Rembrandt van Rijn representing Danaë' in the inventory of the widow of Eduart van Domselaer, 1660 (on the other hand, it is probably not the 'large piece representing Danaë' – corrected to 'Diana' – in Rembrandt's 1656 inventory). According to the classical myth, Danaë was the daughter of the Argive king, Akrisios, who imprisoned her in a tower of brass, with an old nurse as gaoler and companion, because he had been warned by an oracle that any son of hers would kill him. The bound and tearful cupid in brass at the bedhead symbolizes the binding of love in enforced chastity. However, Zeus broke through the prison by disguising himself as a luminous shower of gold. In the picture, Danaë sees only the light, towards which she looks in eager expectation. The mood throughout is radiantly sensual. The immediate pictorial model for the composition was probably a painting by Annibale Carracci, which Rembrandt could have known either in an engraving or a copy. The model for the figure, at least for the face, was certainly not Saskia.

**2. Saskia (?) with One of Her Children** (detail). Red chalk, 14·1 × 10·6 cm. Ben. 280a. London, Count Antoine Seilern.

The identification of the mother with Saskia is supported by comparison with a drawing of *Saskia seated in an Armchair* in the Louvre (Ben. 429). The child may be Rumbartus (1635/6) or Cornelia I (1638), i.e. one of Saskia's first two children, neither of whom lived more than a few weeks. The style of the drawing has the economy and freedom of Rembrandt's most rapid personal sketches; the strokes are straighter, the composition more compact than in drawings of the early 1630's.

**3. The Resurrection of Christ.** Canvas (transferred to panel), 93·4 × 68·7 cm. Signed and dated: *Rembrandt f. 1639*. Br. 56; Bauch 67. Munich, Alte Pinakothek.

Painted for Prince Frederick-Henry of Orange (d. 1647) and in the collection of the House of Orange, Noordeinde Palace, The Hague (inventories, 1662 and 1667), until 1702, when it was bought for the gallery of the Elector Palatine at Düsseldorf; it was transferred to the Alte Pinakothek, Munich, in 1836.

This is one of the last of a series of five paintings on the Passion of Christ painted by Rembrandt for the Stadholder of the Netherlands, Prince Frederick-Henry of Orange (1584–1647). All are now in Munich. The first two were evidently completed by 1633. The commission for the series was probably negotiated through the Stadholder's secretary, Constantyn Huygens (1596–1687). Between 1636 and 1639 Rembrandt wrote seven letters to Huygens, which are mostly about these pictures although little is said in them about art. They are the only letters by Rembrandt known (see H. Gerson, *Seven Letters by Rembrandt*, The Hague, 1961). In the first letter (probably February 1636), Rembrandt explains

that the *Ascension* is complete (it is dated that year) and that the *Resurrection* and *Entombment* are 'more than half done'. In the third letter, dated 12 January 1639, he writes that these two paintings are now finished 'through studious application' and that in them he has expressed 'the greatest and most natural movement' (*die meeste ende die naetureelste beweechgelickheyt*). H. E. van Gelder (*Oud Holland*, LX, 1943) and others have pointed out that *beweechgelickheyt* probably means 'inward emotion' rather than physical movement – see p. 10. In a further letter, accompanying the two pictures when they were despatched, Rembrandt considered that they were worth 1,000 guilders each but he later (13 February 1639) came down to 600 guilders each, plus 44 guilders for the two ebony frames. Rembrandt's association with Frederick-Henry and Huygens possibly began as early as 1629 (see note to pl. 4), and by 1632 there were several paintings by him in the Prince's collection. He portrayed Huygens's brother, Mauritz, in 1632, though not, so far as is known, Huygens himself. In 1646 Rembrandt painted two more pictures of the same size for Frederick-Henry, an *Adoration of the Shepherds* (also Munich) and a *Circumcision* (lost). He received 1,200 guilders each for these two – a high price for medium size paintings.

**4. Landscape with a Windmill.** Reed-pen and wash in bistre, 11 × 24·2 cm. Ben. 1356. Vienna, Albertina.
This is one of Rembrandt's later landscape drawings, c. 1654–55. He abandoned landscape after the mid-1650's.

**5. Sheet of Figure Studies.** Pen and ink and wash, partly covered with white, 18·5 × 17 cm. Ben. 223 *recto*. Berlin, Kupferstichkabinett.
This is typical of Rembrandt's many early studies of beggars and poor people seen in the streets. The date is c. 1633–34.

**6. Studies from the Nude.** Etching, 19·4 × 12·8 cm. Münz 136. Impression in London, British Museum.
This is one of several etchings by Rembrandt executed in the mid-1640's of naked boys. It is reproduced here to illustrate the importance of his study of the nude model, both male and female. A number of drawings of the same boy model are known (Ben. 709–11, A55), each from a slightly different angle and varying greatly in quality. It may be presumed that the boy posed in the studio one day and that Rembrandt's pupils as well as himself sat round in a half-circle and drew him. Scholars disagree as to how many, if any, of the surviving drawings are by Rembrandt, but there is no doubt that the etchings are genuine.
The present example also shows how Rembrandt often treated etching as a practice medium, as if it were pen and ink. The two figures on the sheet are of the same boy and they do not form a single composition, although they are visually related. The faint outline of a nurse playing with a baby in the background is a third separate study.

**7. The Adoration of the Shepherds.** Etching, 14·9 × 19·6 cm. Münz 237 (1st state). Impression in London, British Museum.
This etching was made in the 1650's, according to Münz about 1656–57. By this date Rembrandt habitually used a drypoint needle to supplement the normal process of etching by biting with acid; drypoint lines can be seen particularly in the straw behind the Mother and Child. Like Rembrandt's earlier painting of the subject (1646) in the National Gallery, from which the figure holding the lantern is adapted, the composition is a night scene. In later states of the etching Rembrandt further reduced the light round the Holy Family. For Goethe's

description in *Nach Falkonet und uber Falkonet* (1776), see text, p. 8. In one point the description is inaccurate: the Child is not in His mother's arms but lying beside her in the straw.

**8. Margareta de Geer, Wife of Jacob Trip.** Canvas, 130·5 × 97·5 cm. Br. 394; Bauch 523. London, National Gallery (1675).
Margareta de Geer (1583–1672) was born in Liège and married Jacob Trip in 1603. Her brother, Louis de Geer, was one of the greatest iron-masters and armaments dealers of the period and was associated in business with her husband. There is another, very similar portrait of her by Rembrandt, head and shoulders only, which is also in the National Gallery (Bauch 524); this is dated 1661. As Maclaren points out, the sitter wears a gown and ruff of a type that were in fashion forty years earlier. The handling of the paint, apart from the head, ruff and hands, is unusually free for a commissioned portrait even of this date. The frontal pose and the parallel vertical edges to the gown make the figure seem almost as severe as her husband.

**9. The Dordrecht Merchant, Jacob Trip.** Canvas, 128 × 96 cm. Faintly signed on the right: *Rembr.*. (interrupted by the edge of the canvas, which has probably been cut on this side). Br. 314; Bauch 429. London, National Gallery (1674).
This portrait and its companion (fig. 8) are discussed in detail by Maclaren, *National Gallery Catalogue*, pp. 328–31. At least six other portraits of both Jacob Trip and his wife, Margareta de Geer, are known. They range in date from 1651 to c. 1661, the artists being J. G. Cuyp, Aelbert Cuyp and Nicolaes Maes, in addition to Rembrandt. The identification of the sitters was established by Hofstede de Groot, *Oud Holland*, XLV, 1928, on the basis of the provenance of one of the pairs of portraits from the de Geer family. Jacob Trip (1575–1661) was a merchant of Dordrecht. He was associated with his brother and brother-in-law in the business of manufacturing and trading in armaments. In 1660–62 two of his sons, who were also engaged in the business, had the palatial *Trippenhuis*, one of the greatest Dutch town houses of the period, built for them in Amsterdam. Rembrandt's portrait of Trip in the National Gallery was probably painted about 1660–61, shortly before the sitter's death at the age of 86. For further discussion, see p. 27.

**10. The Militia Company of Captain Frans Banning Cocq ('The Night Watch').** Canvas, 359 × 438 cm. Signed and dated: *Rembrandt f. 1642*. Br. 410; Bauch 537. Pl. 17 is a detail of the painting. Amsterdam, Rijksmuseum (2016).
From the Great Room of the Kloveniersdoelen (the Amsterdam musketeers' place of assembly); transferred in 1715 to the Town Hall; transferred to the Rijskmuseum, 1808.
The literature on this famous painting, which has been almost as much abused as praised, is immense, and no more than a few arbitrarily selected points can be mentioned here. As is shown by early copies, the canvas has been cut, probably when it was moved to the Town Hall in 1715; some 60 centimetres, incorporating two background figures and a baby, have been removed from the left side, and lesser amounts from the other three sides. This unbalances the composition (the arch in the background was originally nearer the centre) and compresses the figures into too confined a space. In all 26 figures are now fully or partly visible, including three children (or dwarfs?), and small parts of five more figures can just be discerned in the background. (For these and other particulars, see Maclaren, *National Gallery Catalogue*, pp. 343–49.) To the right of the arch there is a shield, added later, containing the names of 18 of the persons portrayed. According to two of them who gave

evidence on Rembrandt's behalf in 1658/9, he was paid a total of 1,600 guilders; the sitters contributed an average of 100 guilders each, the sum varying with their prominence in the picture.

A reference in the family album of the captain, Banning Cocq (1605–55), states that the painting shows him directing his lieutenant, Willem van Ruytenburch, to order the company to march out (the captain is in black with a red sash, the lieutenant in yellow carrying a ceremonial lance). Since the cleaning of the picture in 1946/7, if not before, it has been evident that the scene takes place in daylight, with the sun streaming down from the top left. The traditional title, 'The Night Watch', which dates from the late 18th century, is therefore erroneous but it would be absurdly pedantic to try to change it now. Local militia companies were raised during the Dutch war of independence in the 16th century to protect the cities against invasion from the Spanish armies in Flanders, but by Rembrandt's time they were no longer needed for defence except on the frontier and were kept in being for social purposes. It has been presumed that the company in Rembrant's painting is marching out to take part in a shooting competition. The girl to the left of Banning Cocq carries a dead fowl at her girdle, perhaps as a prize or trophy to be awarded to the winner of the match; the choice of bird is no doubt a punning allusion to the captain's name. Another interpretation is that the picture represents the parade of the Amsterdam companies in honour of Marie de Médicis, the exiled Queen Mother of France, on her visit to the Dutch capital in 1638 (see W. Martin, *Van Nachtwacht tot Feeststoet*, Amsterdam, 1947). Apparently several militia companies ordered paintings to commemorate this event. A third view, proposed by W. G. Hellinga (*Rembrandt fecit 1642*, Amsterdam, 1956), is that 'The Night Watch' is an allegory of the triumph of Amsterdam inspired by Vondel's verse drama, *Gysbrecht van Aemstel* (1638). This view has only one dubious piece of evidence in its favour: that the letters 'GYSB' are allegedly visible in the chasing on the lieutenant's armoured collar. However, there is no reference to any allusion of this kind in contemporary documents, and it is out of keeping with Rembrandt's attitude to art and with the normal conception of a group portrait.

However, in its visual approach this painting is far from normal. Some sitters are portrayed much more distinctly than others, and the eighteen who subscribed are supplemented by almost as many more subordinate figures who were included by Rembrandt for pictorial effect. The group portrait is here transformed into an action picture – a work of dazzling inventiveness and splendour, or a wilful obfuscation of a commonplace bourgeois event, according to taste. It marked at once a revolution in, and the swansong of, the militia company portrait, for shortly afterwards the demand for these portraits ceased and artists turned to the quieter, more practical situations of the guild portrait and the portrait of the board of hospital governors. However, one thing is certain: 'The Night Watch' was a success when it was painted. The story that it was disliked by those portrayed in it and that it brought about the decline of Rembrandt's reputation was a romantic fiction invented by the 19th century. Indeed, it is a wonder how this fiction arose, since there is abundant evidence to show that throughout the second half of the 17th century the painting was frequently regarded as Rembrandt's most famous work.

11. **The Sampling-Officers of the Cloth-Makers' Guild of Amsterdam ('The Syndics').** Canvas, 191 × 279 cm. Signed and dated on the tablecloth: *Rembrandt f. 1662*. A second, false signature at the top right: 'Rembrandt f. 1661'. Br. 415; Bauch 540. Pl. 42 is a detail of the painting. Amsterdam, Rijksmuseum (2017).

From the Staalhof (Hall of the Cloth-Makers' Guild) in the Staalstraat, Amsterdam; acquired by the city of Amsterdam and exhibited in the art gallery of the Town Hall, 1771; transferred to the Rijksmuseum, 1808.

This painting is often called *The Syndics*, although this title is strictly incorrect. The figures, whose names are known from contemporary documents, are the controllers of cloth-samples. They were appointed for a year at a time by the burgomaster of Amsterdam to regulate the quality of cloth produced in the city. They were not the governing body of the guild nor did they administer funds but were responsible only to the burgomaster (see H. van de Waal, *Oud Holland*, LXXI, 1956). Thus they did not preside over a public meeting, and the popular notion that the figure second from the left is rising to answer an imaginary interrupter from the audience is a misconception. The main determinant of the composition is the pictorial requirements of the work of art, and Rembrandt considered the relationship of the figures to each other with the utmost care; three drawings survive for the three figures at the left showing that he tried out different positions for them (Ben. 1178–80). As Van de Waal has suggested, the low viewpoint was probably chosen not to indicate that the table is raised on a dais but to correspond to the destined position of the picture high up above a mantelpiece. As this last feature shows, if there was no imaginary audience, there was nevertheless a real one – the observer. At least four of the six figures are fully intent on him, and he is the psychological focus of the composition. The participants are as strongly concentrated on something outside the picture as those in the *Anatomy Lesson of Dr Tulp* are on something inside it.

12. **Doctor Nicolaes Tulp Demonstrating the Anatomy of the Arm.** Canvas, 162·5 × 216·5 cm. Signed and dated: *Rembrandt. f. 1632* (the original signature has been gone over by a restorer). Br. 403; Bauch 530. Pl. 9 is a detail of the painting. The Hague, Mauritshuis (146).

From the Anatomy Theatre of the Surgeon's Guild of Amsterdam; sold in 1828 and bought for the Mauritshuis for 32,000 guilders by King William I of Holland.

This was Rembrandt's first large painting and was the work with which he established his reputation on moving from Leyden to Amsterdam in 1631–32. As Riegl pointed out in his classic study, *Das holländische Gruppenporträt*, 1931, it marked a turning point both in Rembrandt's stylistic development and in the evolution of the Dutch corporation, or guild, portrait. For the first time the figures were unified not merely by token gestures and glances but by their common interest in an event taking place within the composition. Group portraits of surgeons' guilds, usually with a skeleton, had been a recognized category of painting in both the Northern and Southern Netherlands for over fifty years. The surgical dissection of corpses had also been made into established, though not frequent, occasions, with fixed rituals rigidly controlled by the guilds. It was forbidden to hold a dissection, either in public or private, without the guild's permission, and the corpse had to be that of an executed criminal. The only dissection known to have taken place in Amsterdam in 1632 was on 31 January, when the criminal was Adriaen Adriaensz. Dr Nicolaes Pietersz Tulp (1593–1674) was chief anatomist and praelector of the Surgeons' Guild of Amsterdam; he was a follower of the 16th-century Dutch anatomist, Vesalius, and of the Englishman, William Harvey; he was later burgomaster of Amsterdam and curator of the new university.

As W. S. Heckscher has shown (*Rembrandt's Anatomy of Dr Nicolaes Tulp*, New York, 1958), the painting was privately

commissioned by Tulp and the others portrayed in it, not collectively commissioned by the guild (as was usual), as only two of the figures were officers of the guild; the names of the sitters are on the paper held by one of them. Moreover, the painting evidently alludes to a private, not a public, dissection. C. E. Kellet has argued in his important review of Heckscher's book (*Burlington Magazine*, CI, 1959, pp. 150–2) that it was at these private dissections, which were allowed prior to or following the public ones, that scientific knowledge was chiefly advanced. Public dissections, by contrast, had developed by this time into occasions for elaborate ceremonial and further symbolic 'punishment' of the criminal. They regularly began with the opening of the stomach (cf. *The Anatomy Lesson of Dr Deyman*, pl. 38), not the arm. According to Kellet, 'Dr Tulp is shown demonstrating to a few of his friends a classical dissection and comparing his findings . . . with the magnificent new copperplates by Casserius which adorn the *Anatomy* of his countryman, Adriaen van der Spieghel, published in Venice in 1627.' The book is presumably this book, open at the plate showing the muscles and tendons of the forearm and hand.

Even so, it is not easy to see the painting as an exact illustration of a particular event. Apart from the contrivance of the grouping, the dissected arm is seemingly not the corpse's arm, nor is it necessarily the case that all seven onlookers would have been present. (It has been suggested that two of them – the man in the background rising above the others and the one on the extreme left – are additions to the original composition, the second perhaps not by Rembrandt himself). Essentially the picture is to be regarded as a symbolic rather than a documentary reconstruction of one of Dr Tulp's anatomical demonstrations, perhaps the one in which he took most pride or for which he was most famous. The persons portrayed would have been admirers of his who helped pay for the picture, while the form of the composition would have been determined chiefly by pictorial considerations.

13. **The Conspiracy of Julius Civilis: The Oath** (fragment). Canvas, 196 × 309 cm. Br. 482; Bauch 108. Pl. 43 is a detail of the painting. Stockholm, Nationalmuseum.

The subject is from Tacitus, *Historiae* IV, 13–16, which tells of the revolt of the Batavians, the original inhabitants of Holland, against the occupying Romans. The leader of the revolt was Julius Civilis (also called Claudius Civilis), who assembled the chiefs of the Batavians in a sacred wood under the pretence of a banquet. There he made them swear an oath to fight for their liberty: he is described by Tacitus as having only one eye. The revolt was seen by the Dutch as an antetype of their own successful struggle for independence against the Spaniards in the 16th century and was often illustrated by 17th-century painters and engravers.

Rembrandt painted the picture as the first episode in a series of eight canvases (by different artists) illustrating the story of the revolt, which were designed to fill the lunettes of a high gallery in the newly built Town Hall of Amsterdam. He received the commission almost certainly in 1661 and his painting was in place in 1662. However, it was removed almost immediately for alterations, perhaps at the request of the authorities, and it was never returned to the Town Hall. In 1663 it was replaced by a canvas by Rembrandt's pupil, Juriaen Ovens. The exact reason why Rembrandt's painting was removed – or rather, not returned – is still a mystery. The most obvious explanation would be that its style was disliked, but Rembrandt may have been faulted on a technicality, namely that he had not followed an engraving after a painting by Otto van Veen, as he was seemingly asked to do. Alternatively, the shape of the vault of the gallery may have been altered between the date of the commission (when a temporary wooden vault was in place) and the delivery of the picture. (For a summary of the relevant arguments, see W. Stechow, *Art Bulletin*, XXIII, 1941). It seems that Rembrandt himself cut the painting down and repainted the central part to make it more saleable. In its original form it was no less than 5½ metres in both dimensions (larger than '*The Night Watch*'), with an oval top. A drawing in Munich (Ben. 1061) shows the composition before it was reduced. The figures round the table were flanked on either side by servants and onlookers, and the table itself and the conspirators were seen across a vast empty foreground at the head of a broad flight of steps. Behind the figures was a backcloth and above that a huge vault.

# List of Collections